To Ina "howling wind"

with love

Thank you for reflecting Power
Beauty & Substance. the beauty true magik
of the Feminine. And do your open heart
I will carry this reflection
in my heart alway

Dancing Fire women
(Sheenae)

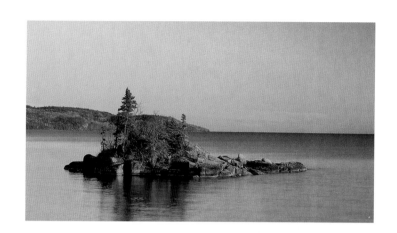

ONTARIO

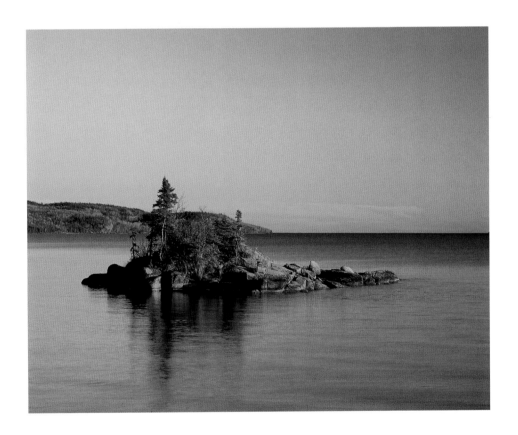

WHITECAP BOOKS
VANCOUVER / TORONTO

Cover and book design by Steve Penner
Cover photograph by Richard Hartmier / First Light
Text by Tanya Lloyd
Edited by Elaine Jones
Proofread by Lisa Collins
Photo editing by Pat Crowe

Printed and bound in Canada by Friesens, Altona, Manitoba.

Canadian Cataloguing in Publication Data

Lloyd, Tanya, 1973-

 Ontario

 ISBN 1-55110-523-3

 1. Ontario--Pictorial works. I. Title. II. Series:
Lloyd,Tanya, 1973.
FC3062.L66 1997 971.3'04'0222 C96-910740-4
F1057.8.L66 1997

The publisher acknowledges the support of the Canada Council and the
Cultural Services Branch of the Government of British Columbia in making
this publication possible.

For more information on this series and other Whitecap
Books titles, visit our web site at www.whitecap.ca.

In the heart of the Canadian Shield, a lone canoeist paddles through the early morning mist. This is an image that captures Ontario's essence, a waterscape rather than landscape. More than 170,000 square kilometres of the province is water—an interconnecting array of marshlands, rivers, and lakes that first carried European settlers across the province and still permeates the local way of life.

Water is central to both industry and recreation. The grain from the picturesque farmlands of southwestern Ontario is carried by ships from Thunder Bay through the Great Lakes and down the St. Lawrence for export to countries around the world. Meanwhile, in small towns such as Gananoque, residents spend summer days fishing and boating.

Each of Ontario's riverside towns is filled with intriguing stories. From the First Nations legend of creation on Manitoulin Island to the heart-wrenching story of the end of Terry Fox's run near Thunder Bay, each community boasts an eventful history. In Queenston, visitors can tour the restored home of Laura Secord, a hero who ran 30 kilometres during the War of 1812 to warn the British of an impending attack. In Perth, the pistols used in Canada's last fatal duel are on display in the local museum.

Of course, Ontario is not all small towns and waterways. Toronto, the nation's largest city, combines the high-energy bustle of downtown with the character buildings and art vendors of Queen Street West. Just a few hours away, the nation's future is debated in the capital city of Ottawa.

Ninety percent of Ontario's people live along the southern border, most of them in cities. While this creates a bustling urban atmosphere of culture and industry, it leaves most of the land virtually uninhabited, filled with wilderness attractions, such as Algonquin Provincial Park and the La Cloche Mountain Range in Killarney Provincial Park. These places inspired Canada's most famous painters, the Group of Seven, and continue to draw thousands of visitors each year.

The stillness of a summer evening on one of Ontario's countless lakes provides an escape from the bustle of nearby cities.

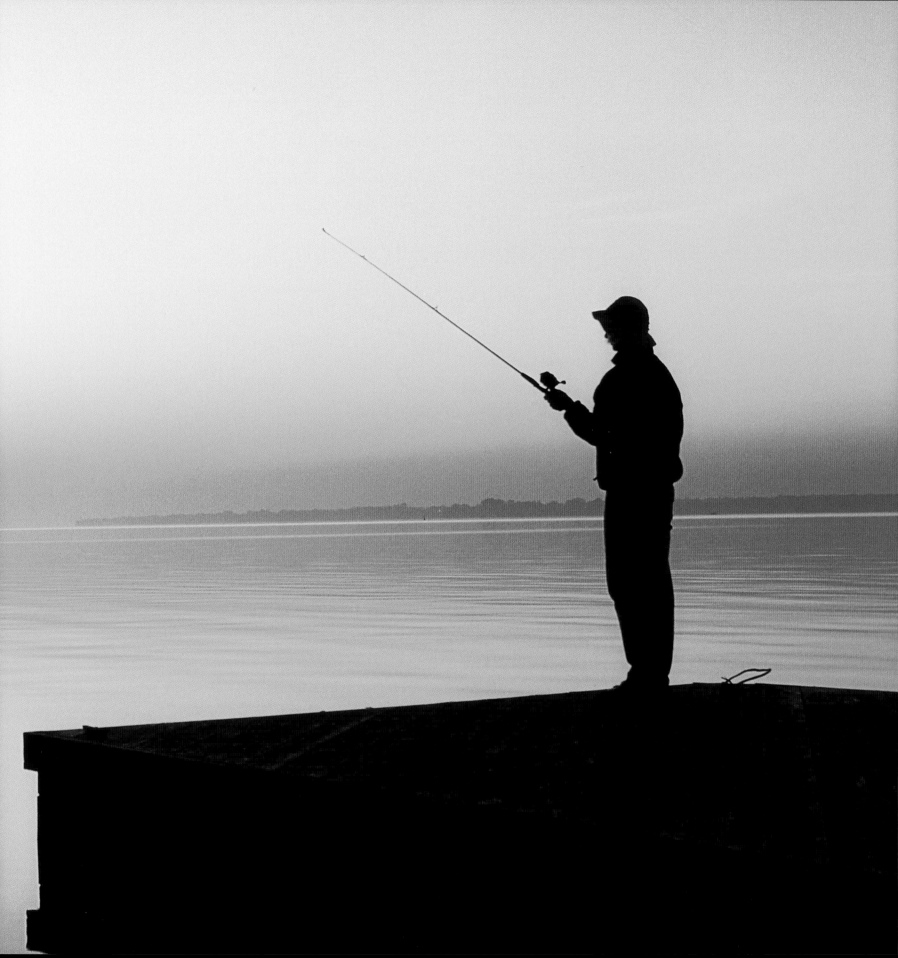

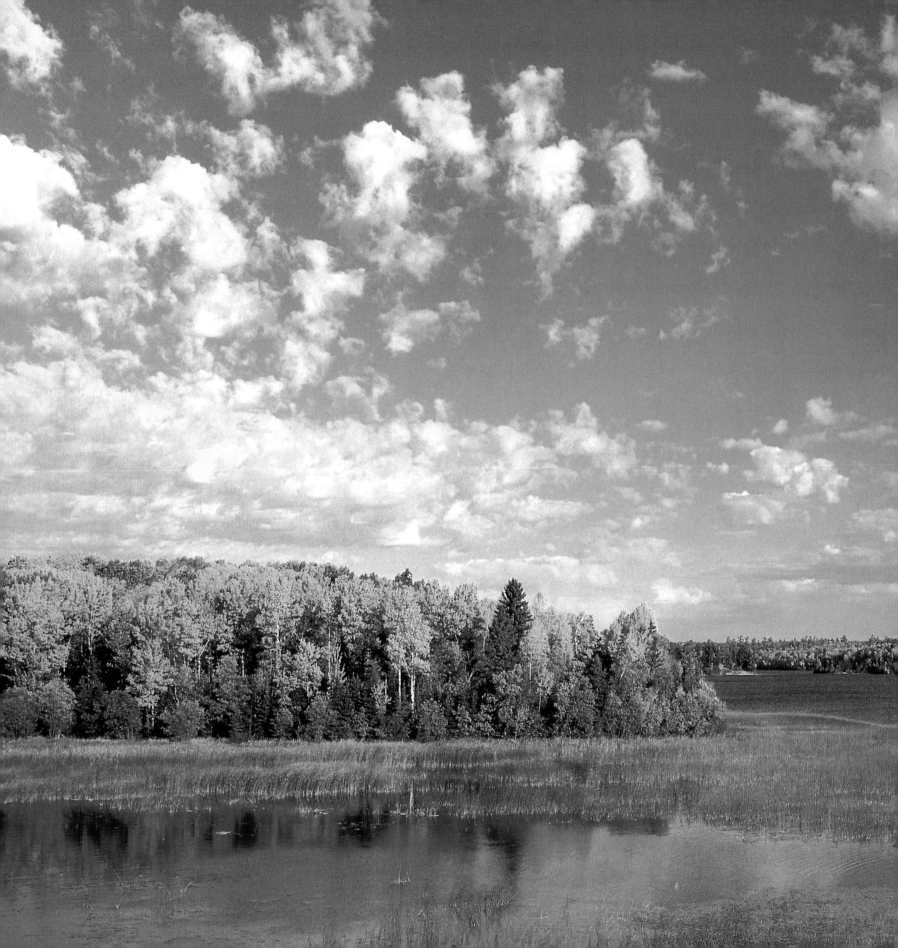

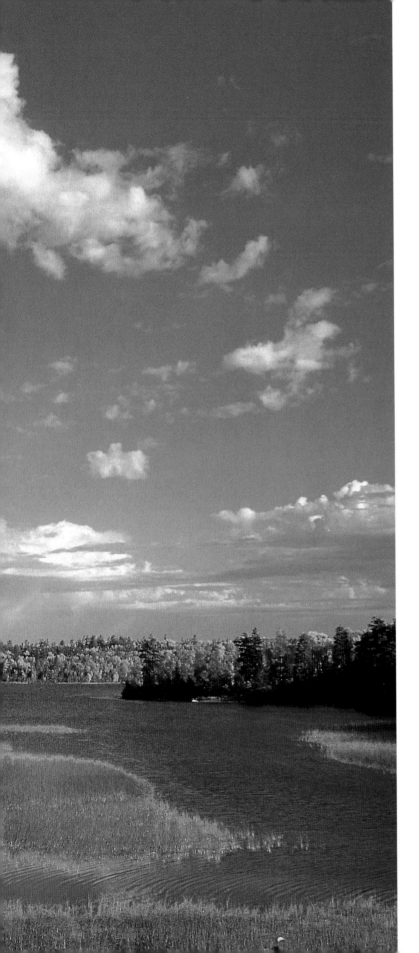

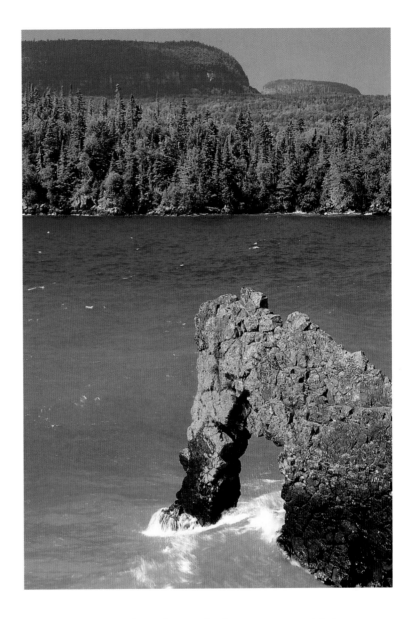

According to Ojibwa legend, the mesas, or high plateaus, in Sleeping Giant Provincial Park are the form of the Great Spirit Nanibijou. The giant told the native people the location of silver, but warned them not to tell the Europeans. When he was betrayed, Nanibijou raised a storm and killed the Europeans. He turned to stone that night.

The picturesque area surrounding the resort town of Sioux Narrows is a popular camping and fishing destination.

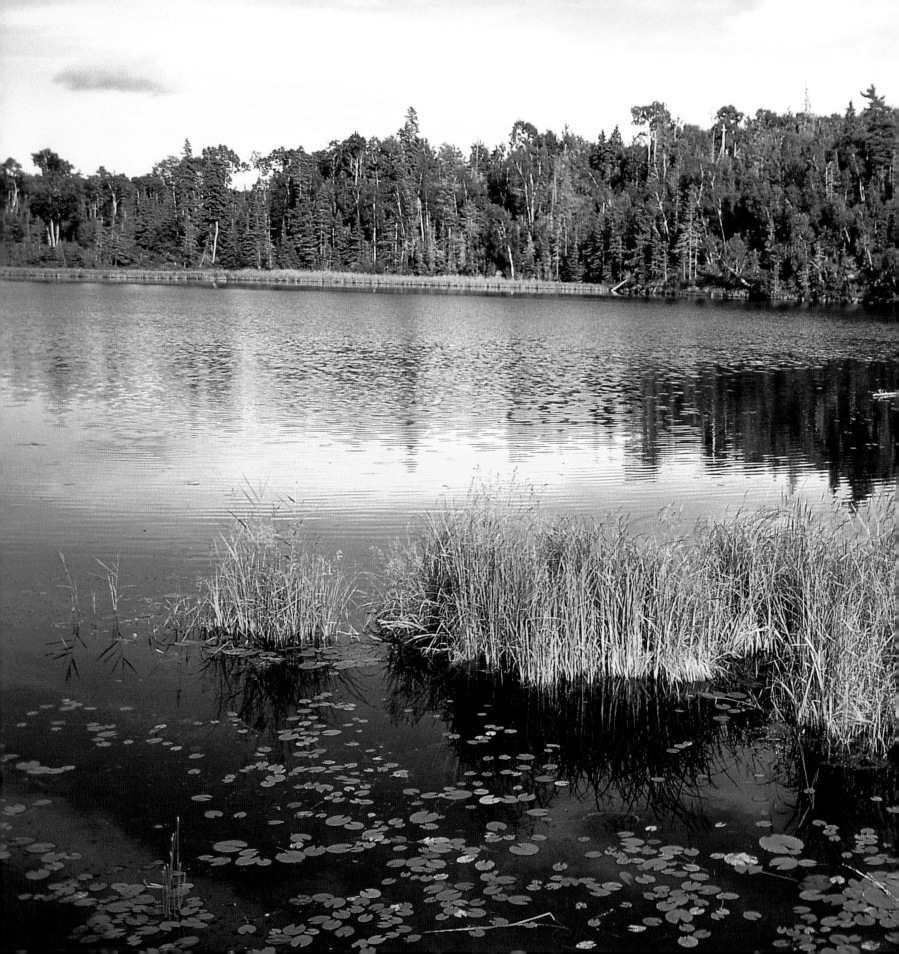

With 105,000 kilo-metres of shoreline and thousands of islands, Lake of the Woods attracts hikers and anglers as well as a large array of birds, including white pelicans and bald eagles.

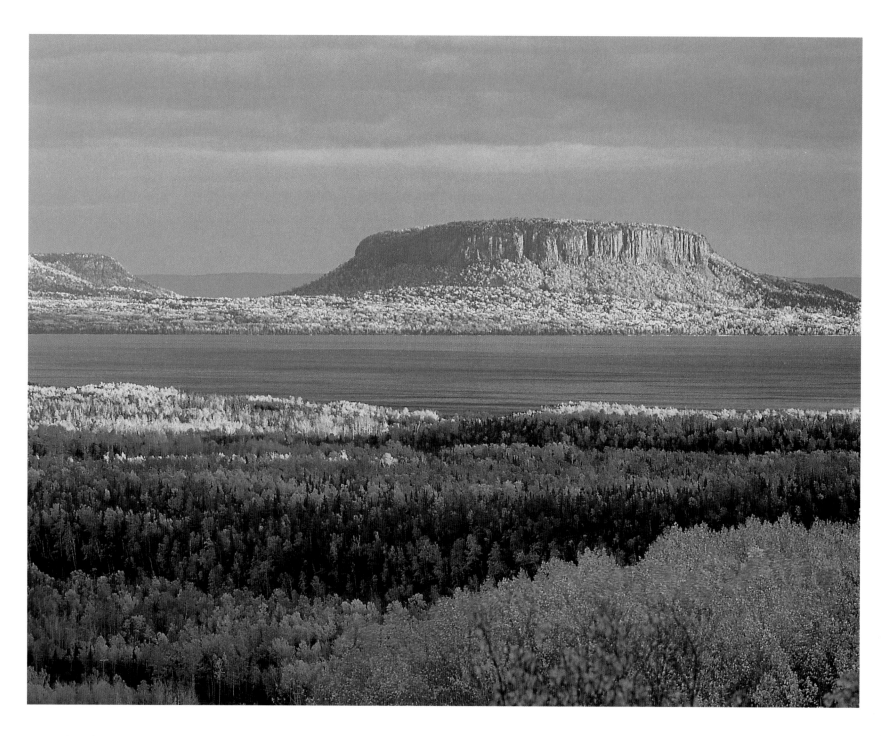

Pie Island is one of the arresting mesas in the Thunder Bay area.

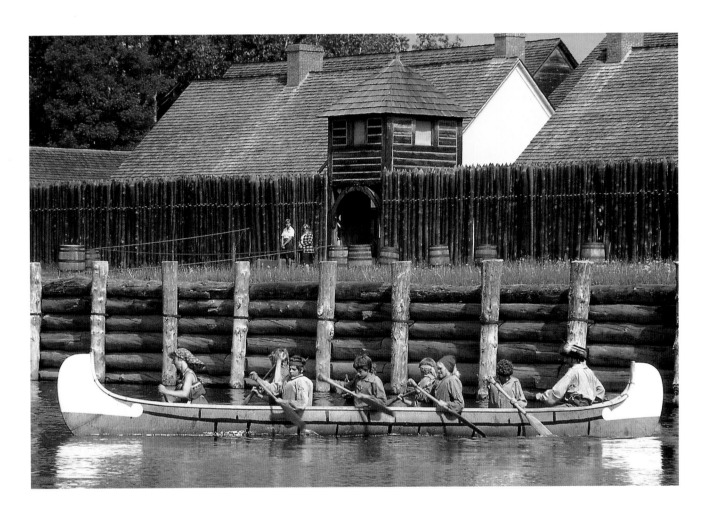

A replica of Fort William stands near its original site. Built in 1803 by the North West Company, Fort William was the first European settlement at present-day Thunder Bay. Each summer, a six-week convention at the fort brought thousands of voyageurs from the interior to meet with fur traders from the east.

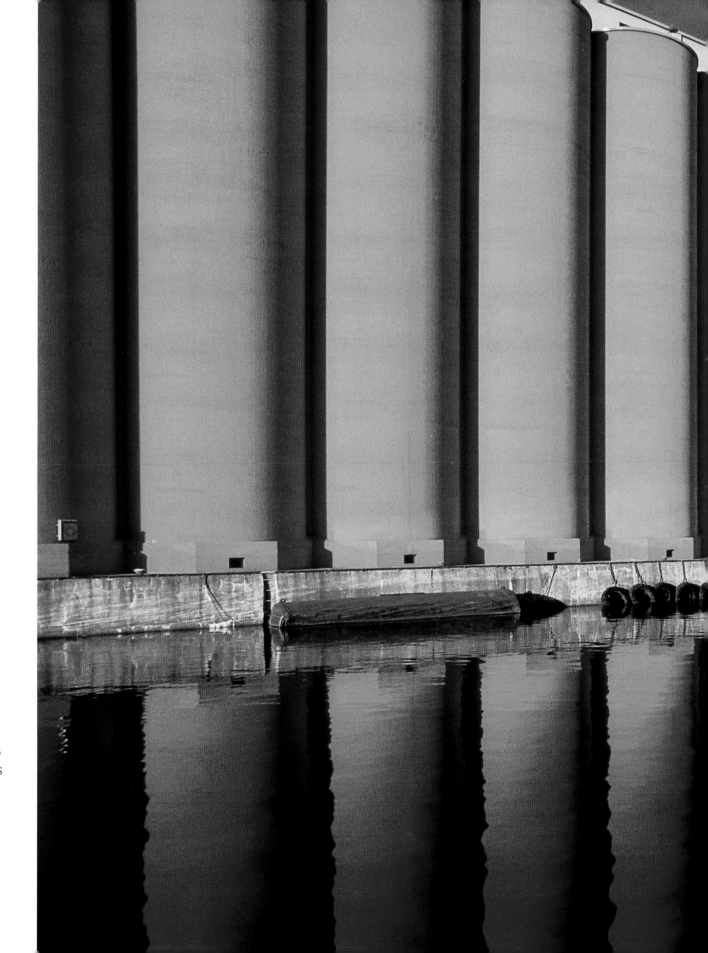

Grain elevators line Lake Superior at the port city of Thunder Bay. The grain gathered here is shipped down the Great Lakes for export to countries around the world, including Italy, Iran, Algeria, France, Russia, and the United States.

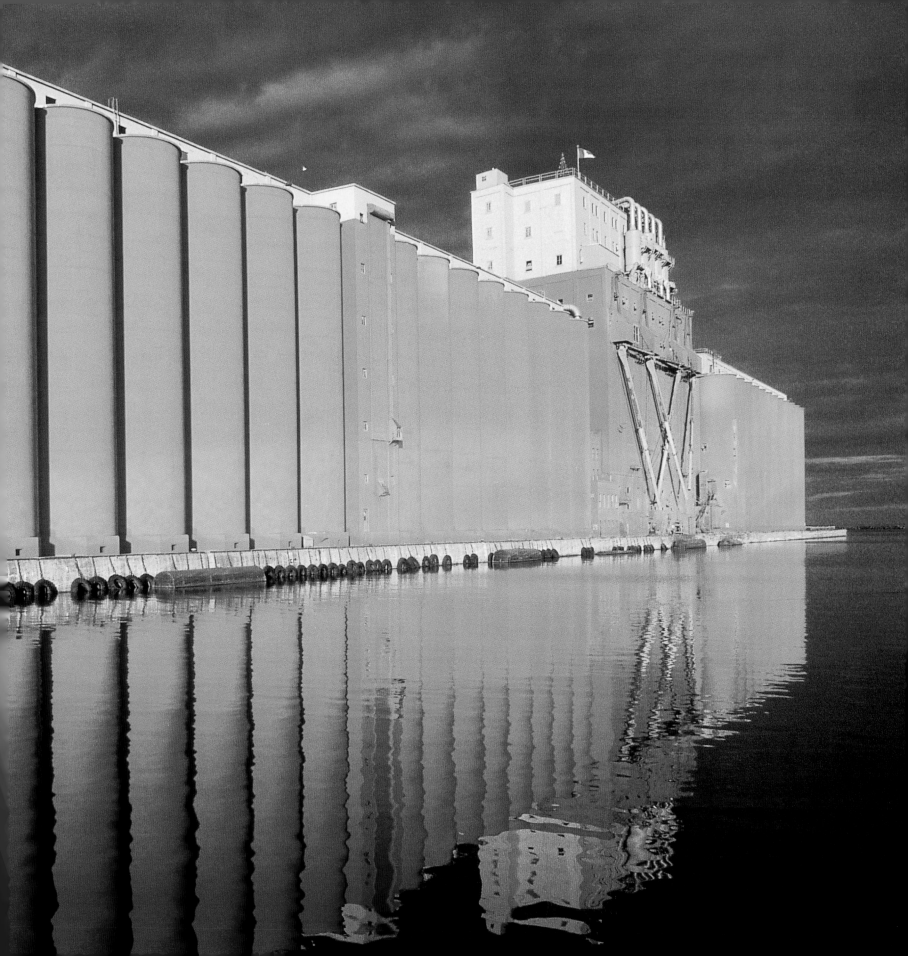

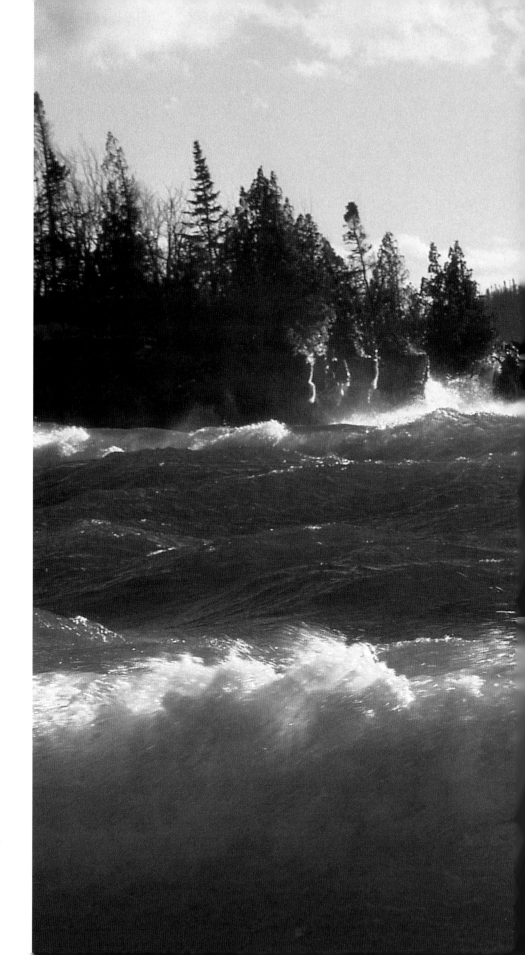

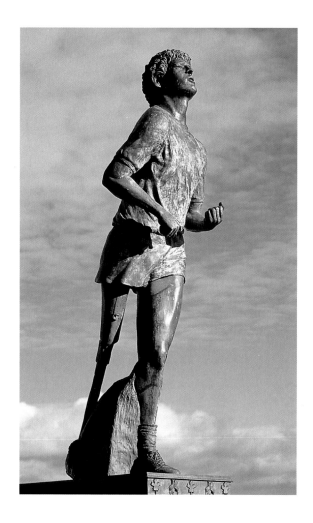

In 1980, having lost one leg to cancer, 21-year-old Terry Fox set out to run across Canada to raise money for cancer research. Just outside Thunder Bay, the disease forced him to abandon his journey. Fox died in 1981, but monuments and commemorative runs across Canada honour his memory.

Stretching for 28,700 square kilometres in Canada and 53,400 in the United States, Lake Superior is Canada's largest lake. Its icy waters support rare species of Arctic plants. The shore is also home to 40 woodland caribou—the only herd to live this far south.

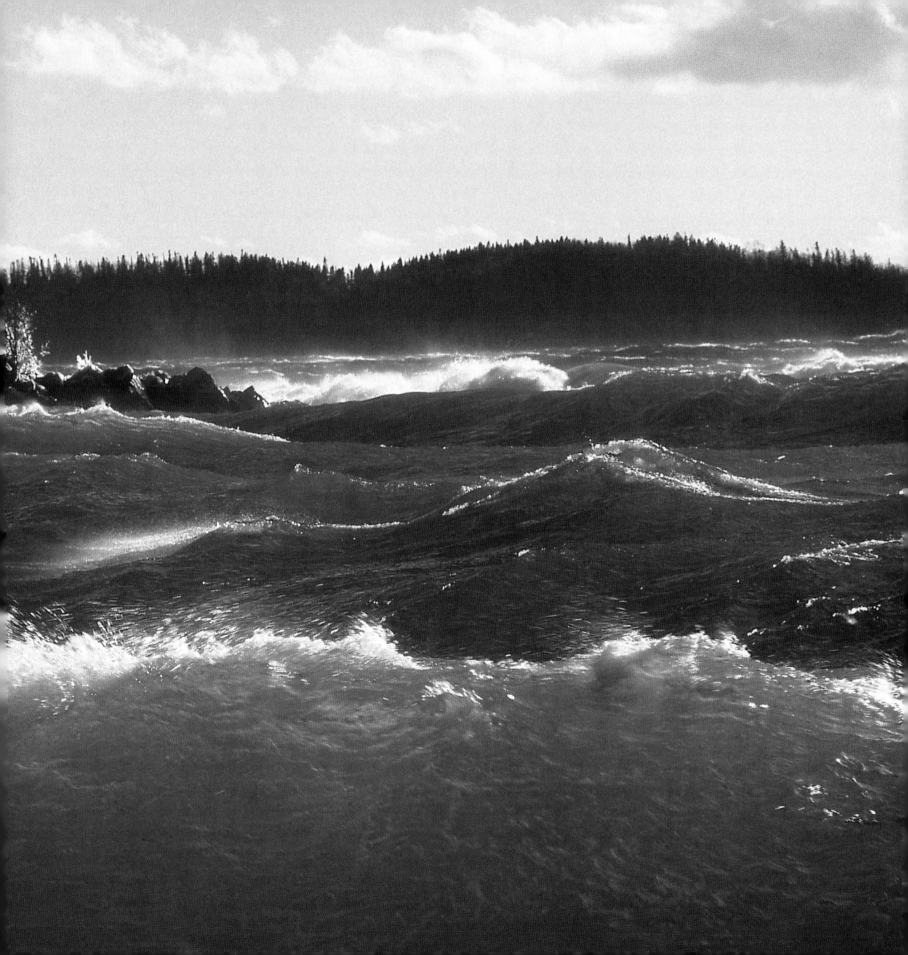

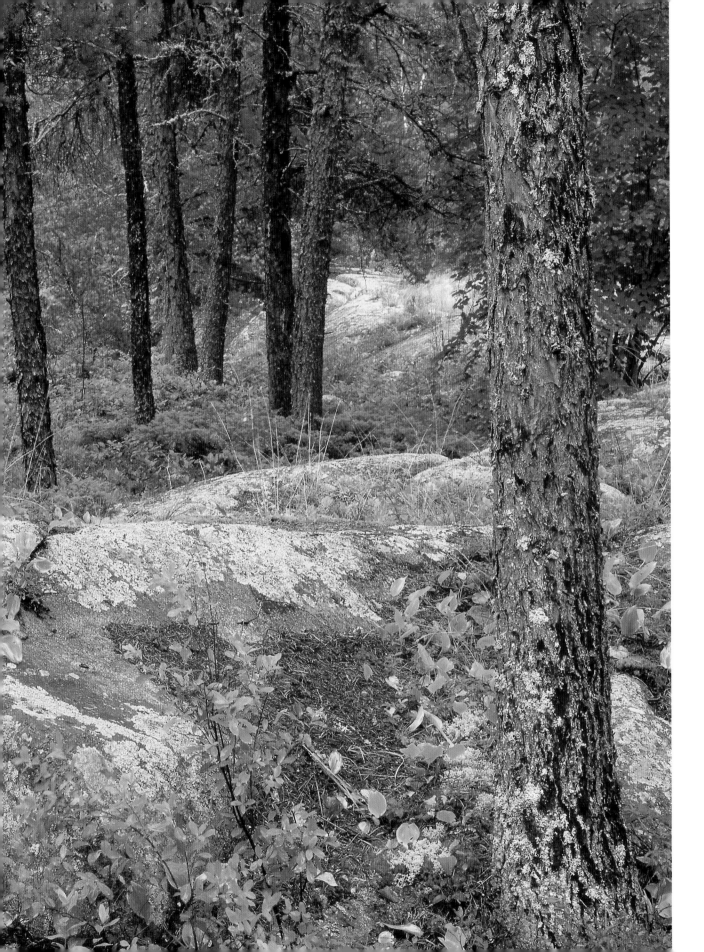

A vast, rugged region of bedrock, rivers, and forests, the Canadian Shield covers two-thirds of Ontario.

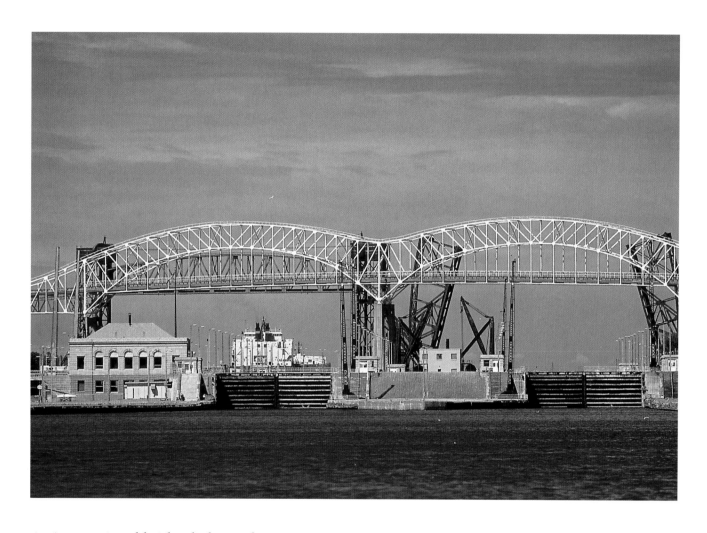

An international bridge links Sault Ste. Marie, Ontario, with Sault Ste. Marie, Michigan. The Soo locks are also an international undertaking; four locks on the American side and four on the Canadian carry ships over the rapids between Lakes Superior and Huron.

The area near Rossport was once a base for fishing. Since the industry's decline, the town relies on its serene surroundings to draw anglers, campers, and sailors.

OVERLEAF –
Known as the crown jewel of Ontario's provincial park system, 48,500-hectare Killarney Provincial Park provides inspiring scenery at the western edge of Georgian Bay. The park is accessible by foot or canoe.

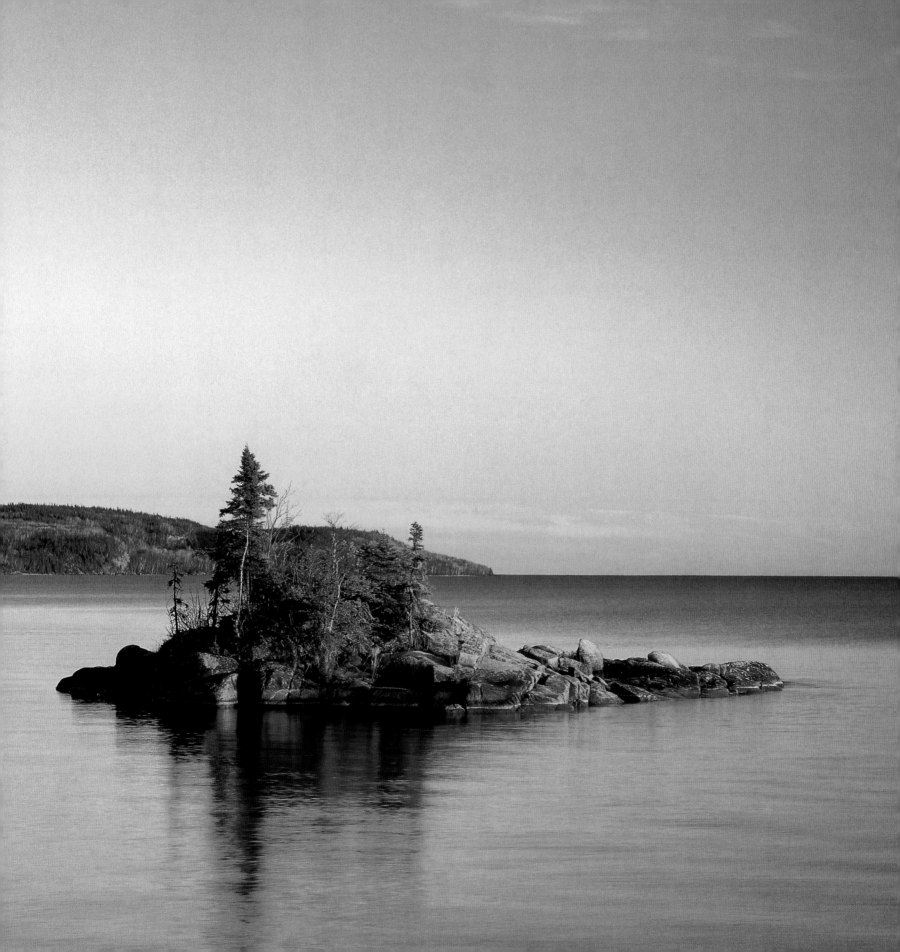

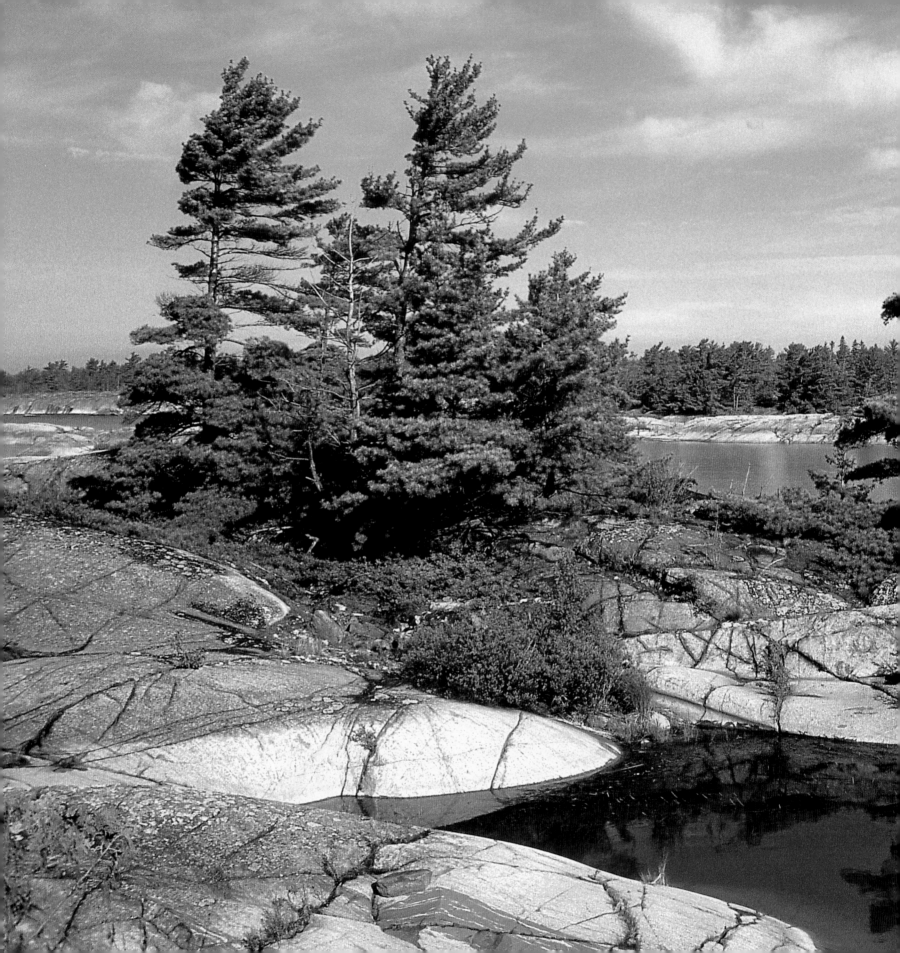

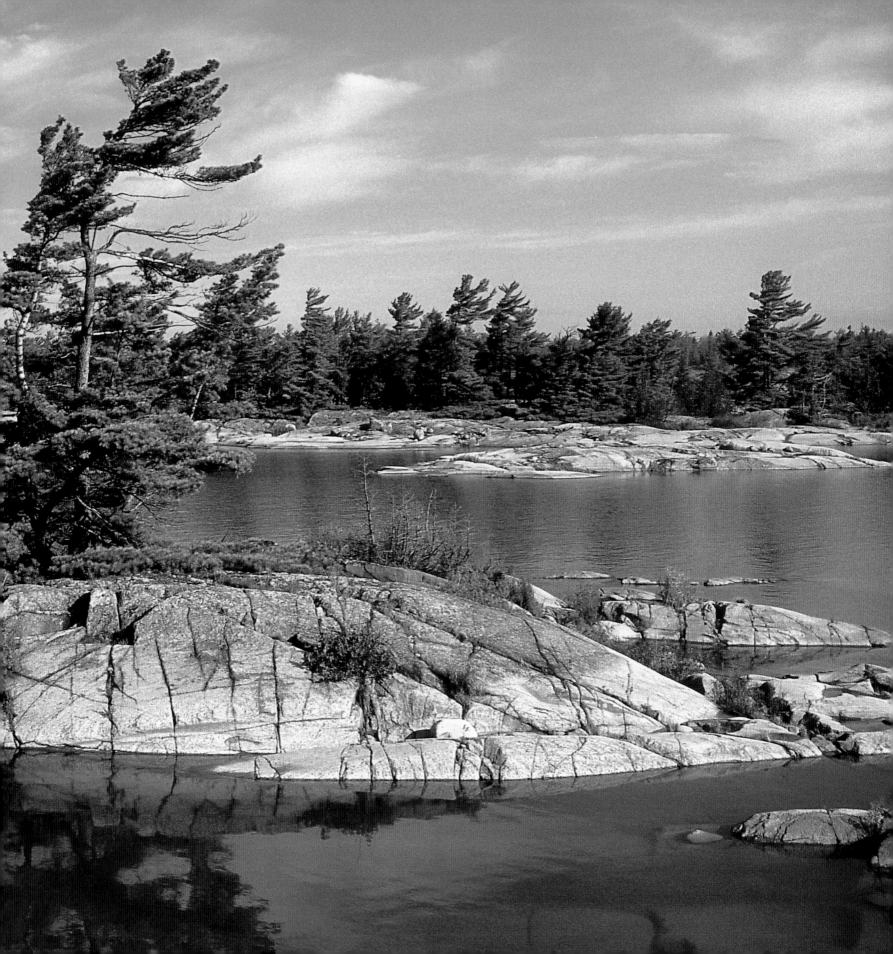

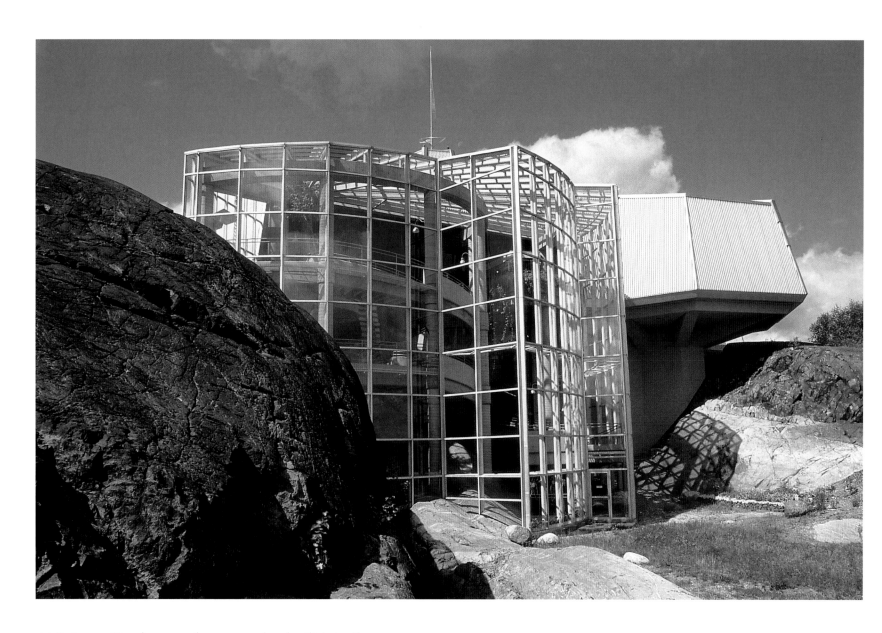

At Science North, a modern complex built into the rock just outside of Sudbury, visitors build sailboats, monitor earthquakes, identify fossils, and experience the thrills of hands-on experiments.

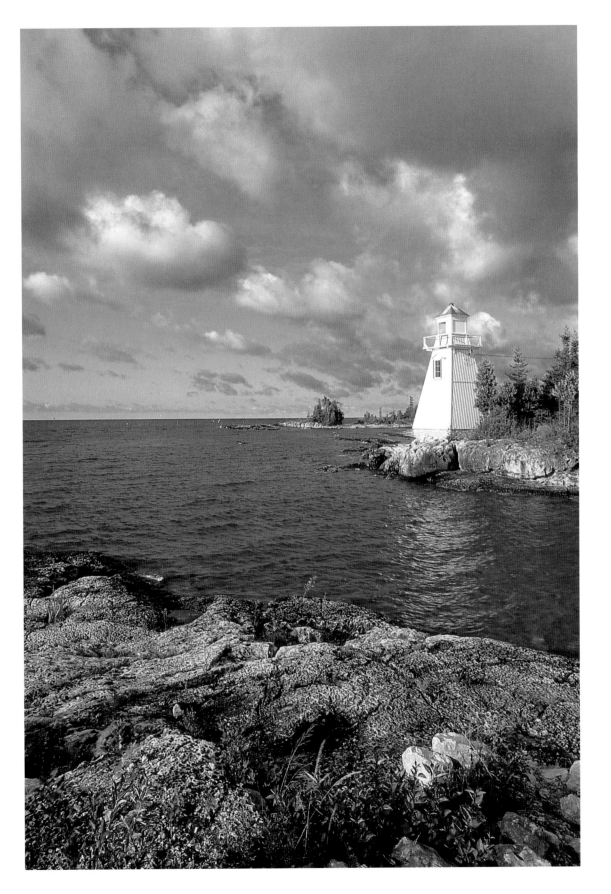

The world's largest freshwater island is Manitoulin Island at the mouth of Georgian Bay. A lighthouse built in 1870 marks the island's west end.

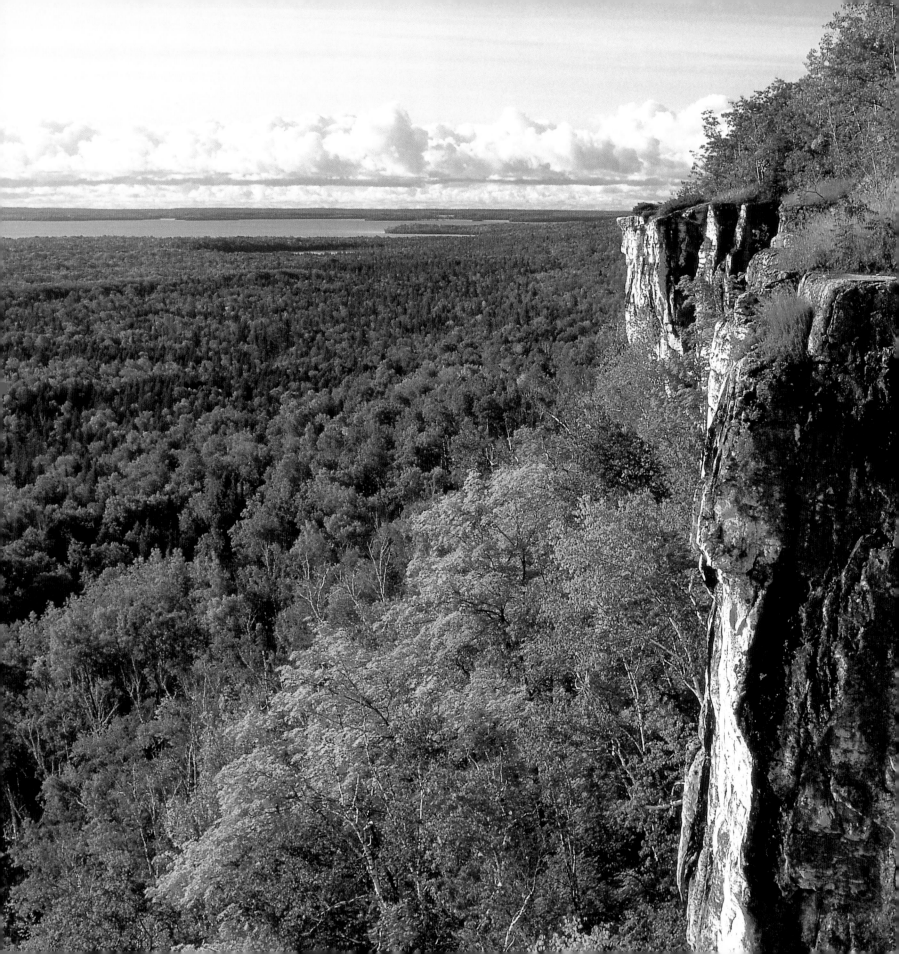

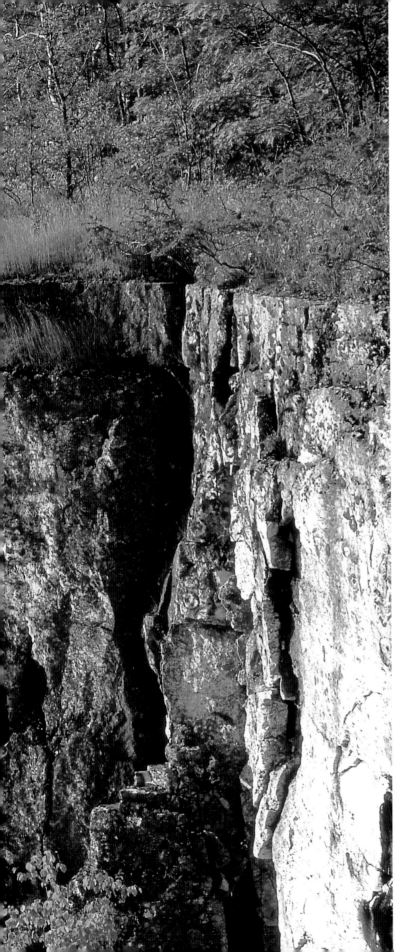

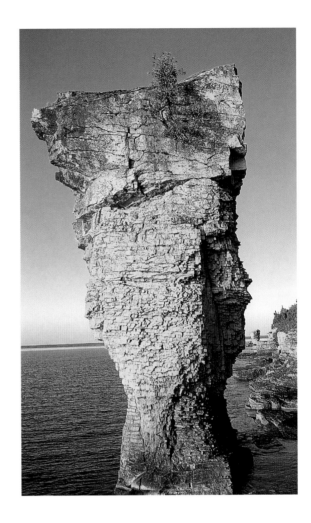

Around Flowerpot Island, the waves have eroded the soft limestone to create striking rock pillars. Because dwarf trees and bushes are anchored to the tops of the pillars, they have been dubbed flowerpots. Once, this limestone was part of an ancient sea and marine fossils remain in the stone.

According to a First Nations legend, the Great Spirit first created life on Manitoulin Island. Today, it's a favourite with outdoor enthusiasts who hike the Cup and Saucer Trail past thick forest and intriguing rock formations.

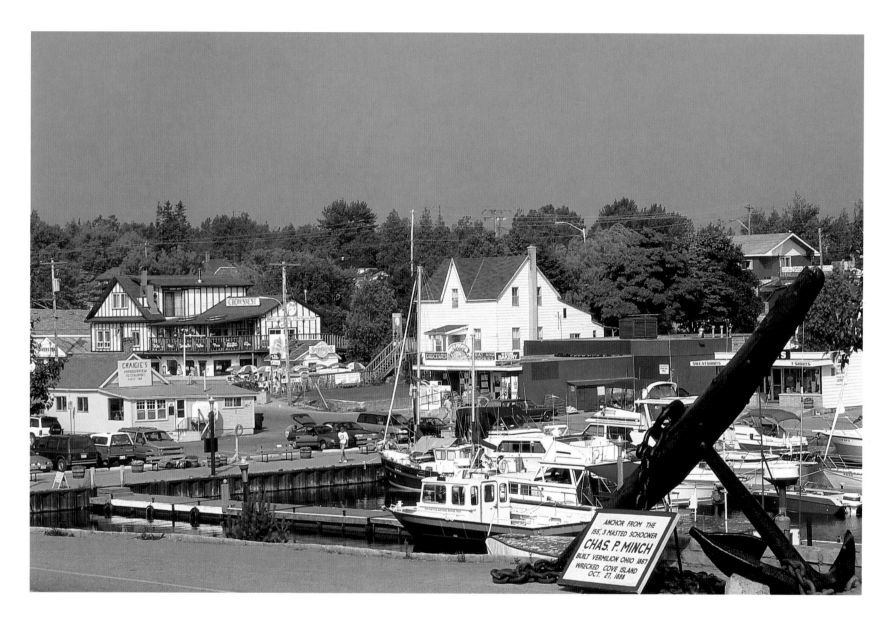

The tiny town of Tobermory serves as a base for visitors
who wish to explore the parks that line the Bruce Peninsula.

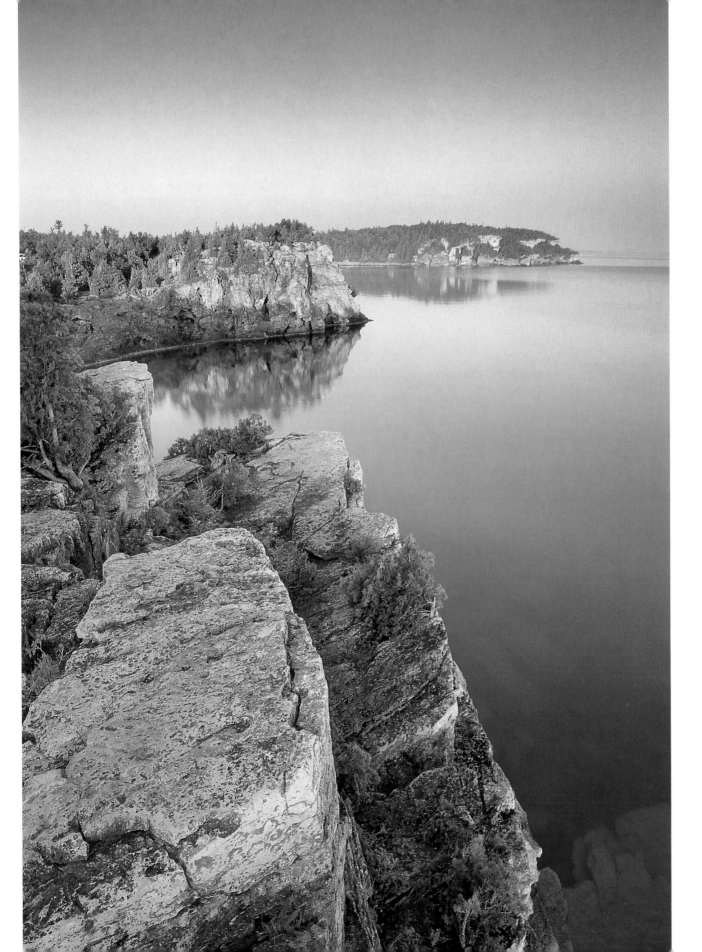

Rugged cliffs drop
to Lake Huron from
Bruce Peninsula
National Park.

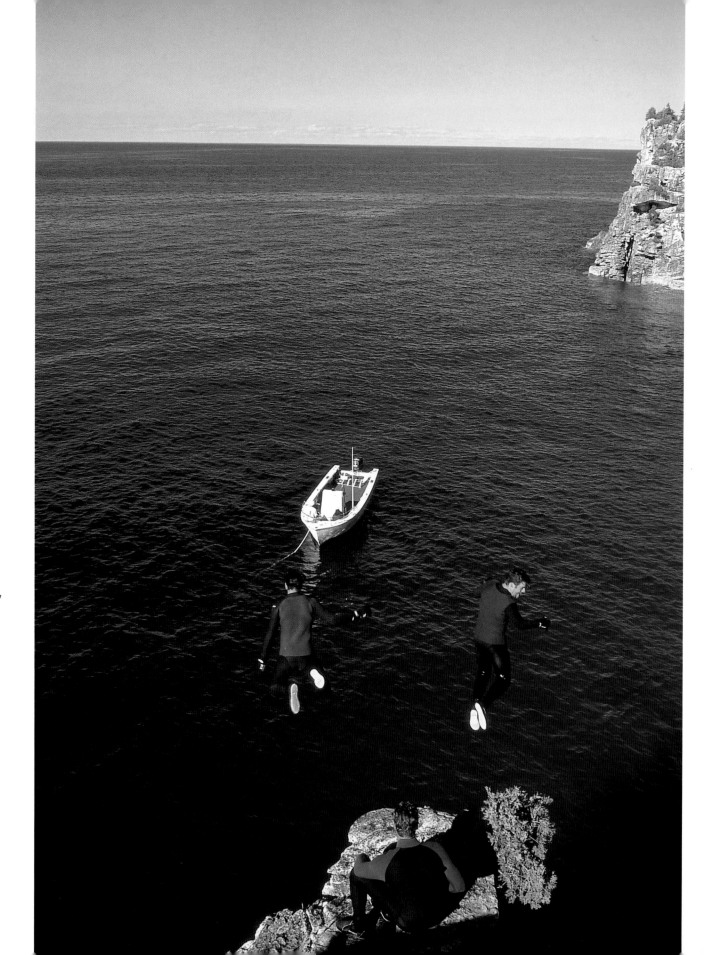

Several prime scuba diving locations surround the Bruce Peninsula. The largest, Fathom Five National Marine Park, protects a unique underwater landscape including more than 20 sunken ships.

Queen Elizabeth once called Goderich the prettiest town in Canada. The eight streets radiating from the octagonal town centre are lined with gardens and character homes.

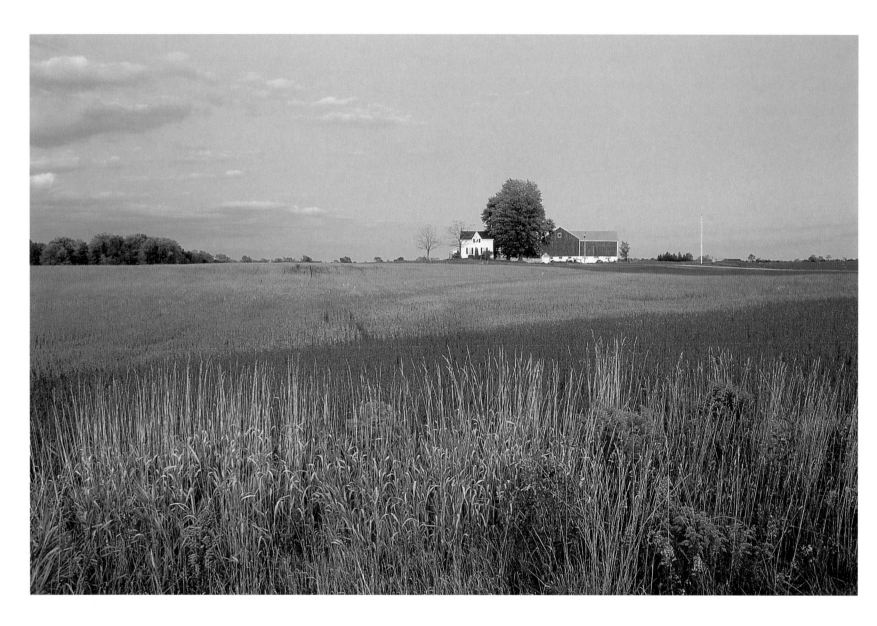

Ontario produces an annual wheat crop valued at more than $100 million, making the province Canada's fourth-largest producer. Ontario leads the country in the production of poultry, dairy products, vegetables, and eggs.

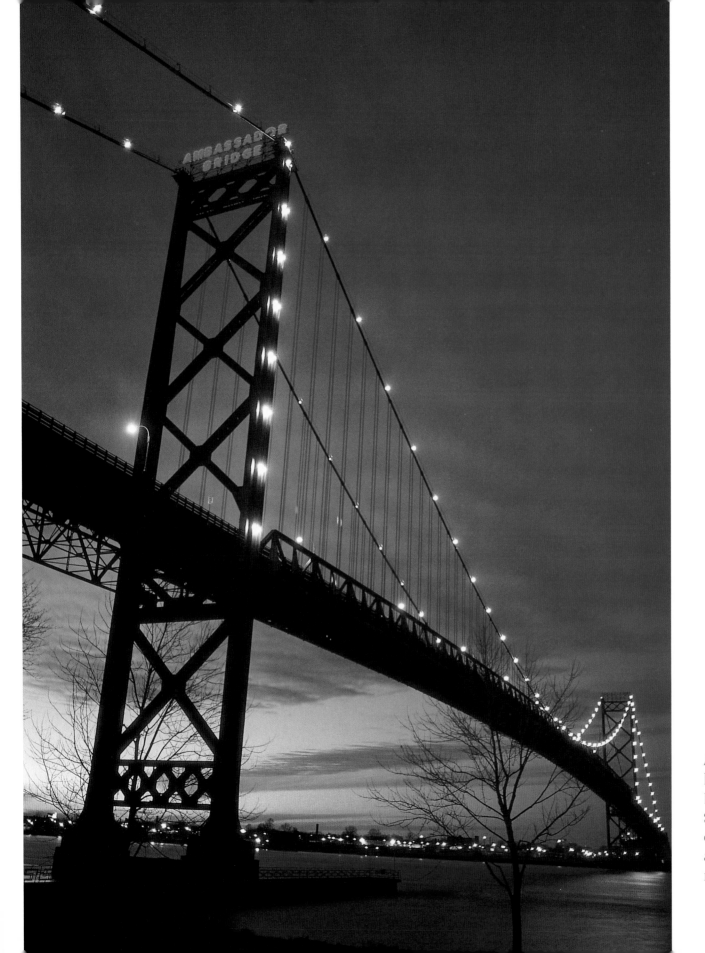

Ambassador Bridge links Windsor with Detroit in the United States. Both cities are centres for industry and automobile manufacturing.

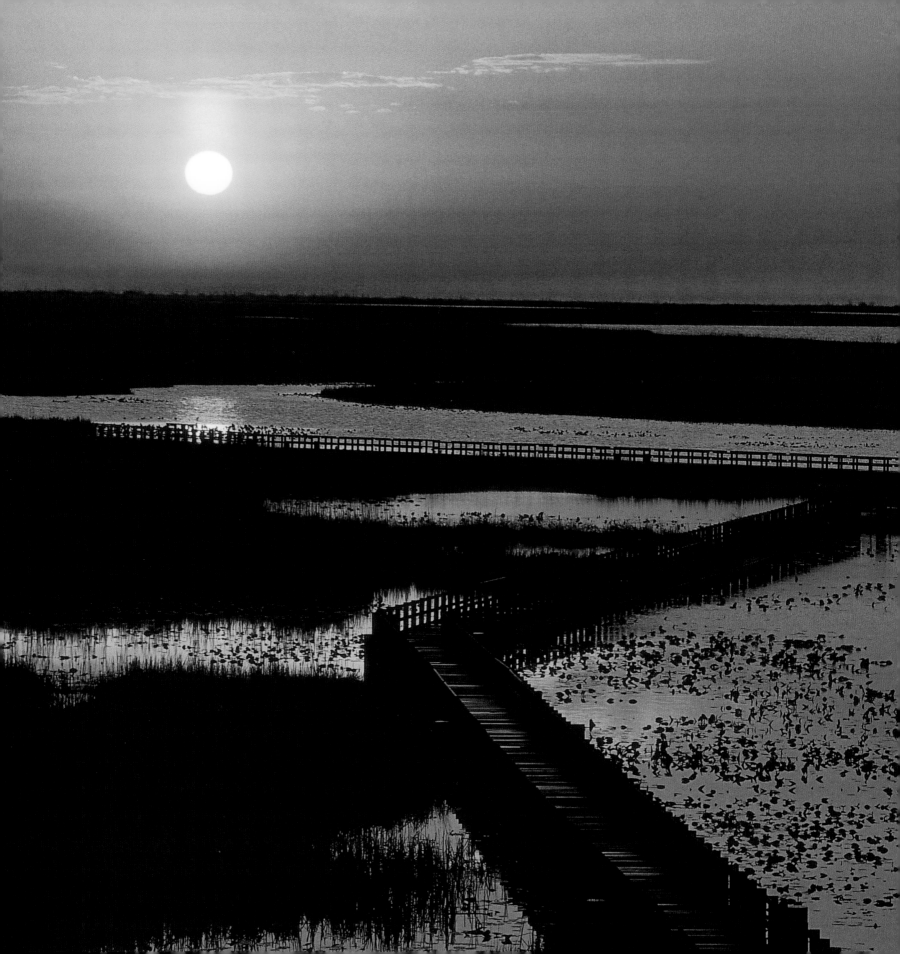

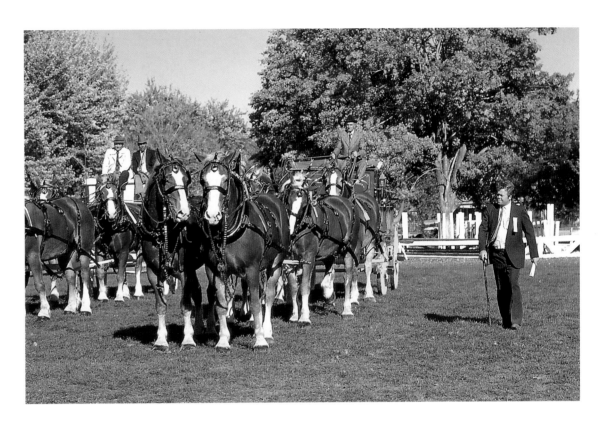

Work horses stand for inspection at the Norfolk County Fair in Simcoe.

At Canada's southernmost tip, Point Pelee is at the same latitude as northern California. But instead of bikini watchers, these shores attract bird watchers. Thousands of birds stop here on their annual migrations, and they are joined each fall by flights of monarch butterflies.

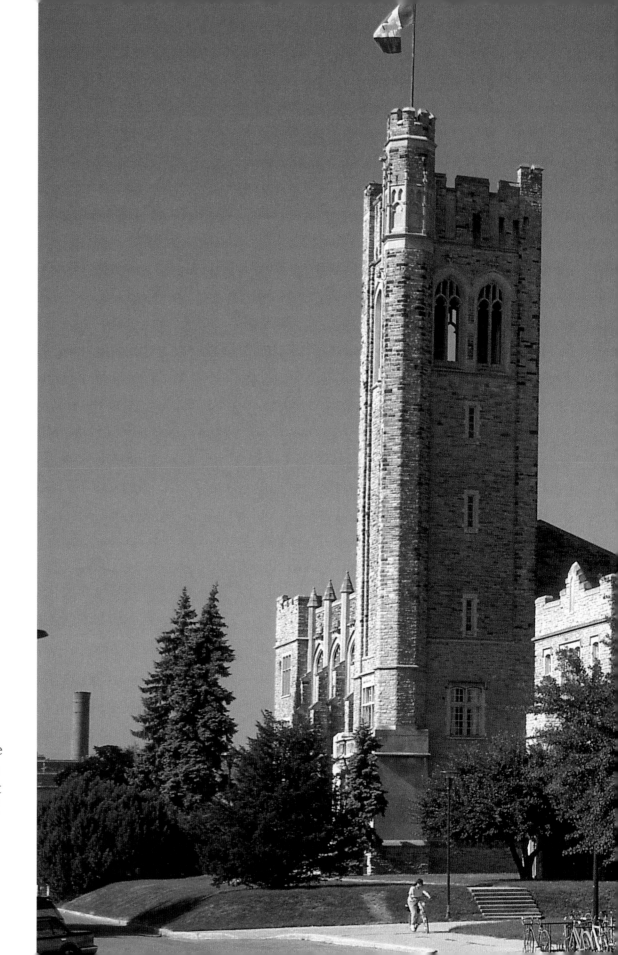

With more than 26,000 students, the University of Western Ontario is the province's third-largest university. It was founded in 1878 just outside of London.

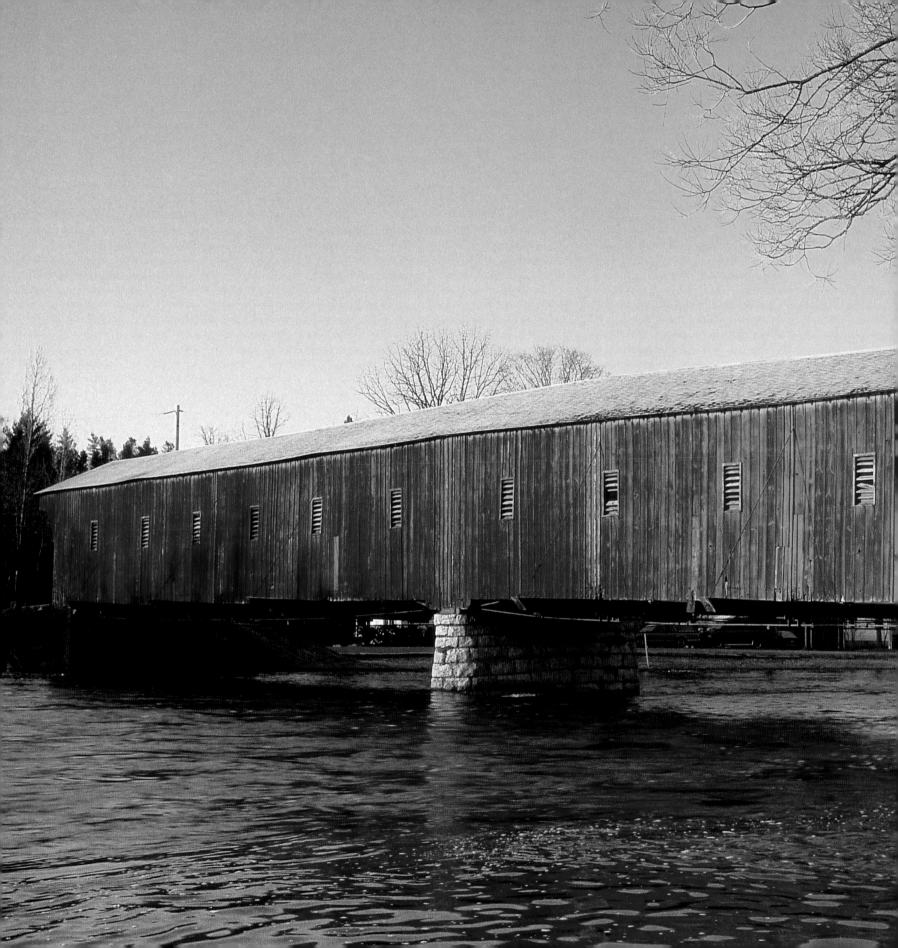

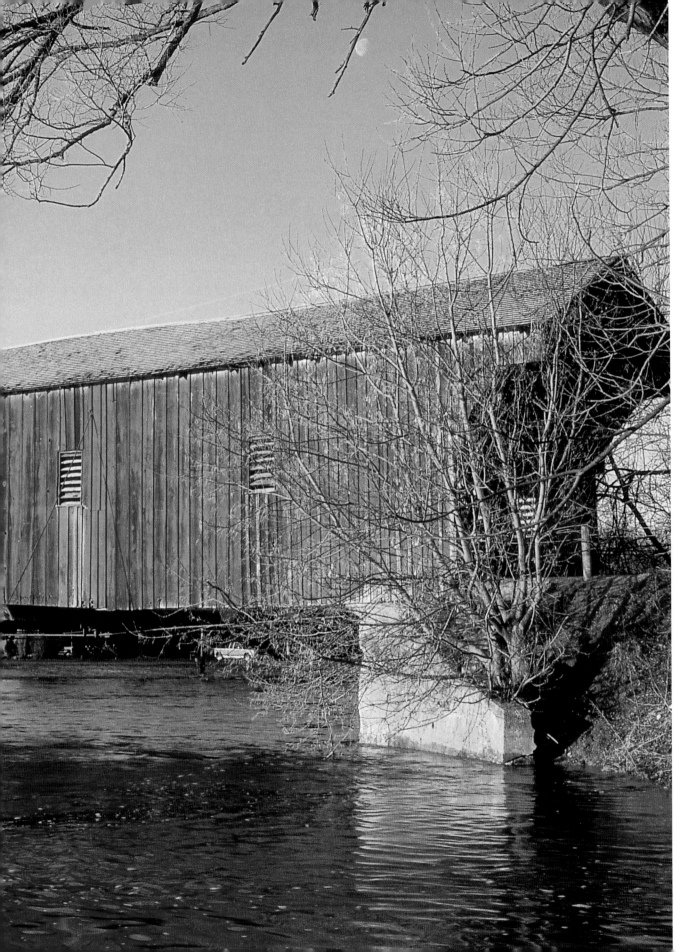

A horse-drawn carriage, a dimly lit spot . . . it's easy to guess how Ontario's last covered bridge earned the name "Kissing Bridge." The 60-metre bridge was built in 1881 in West Montrose.

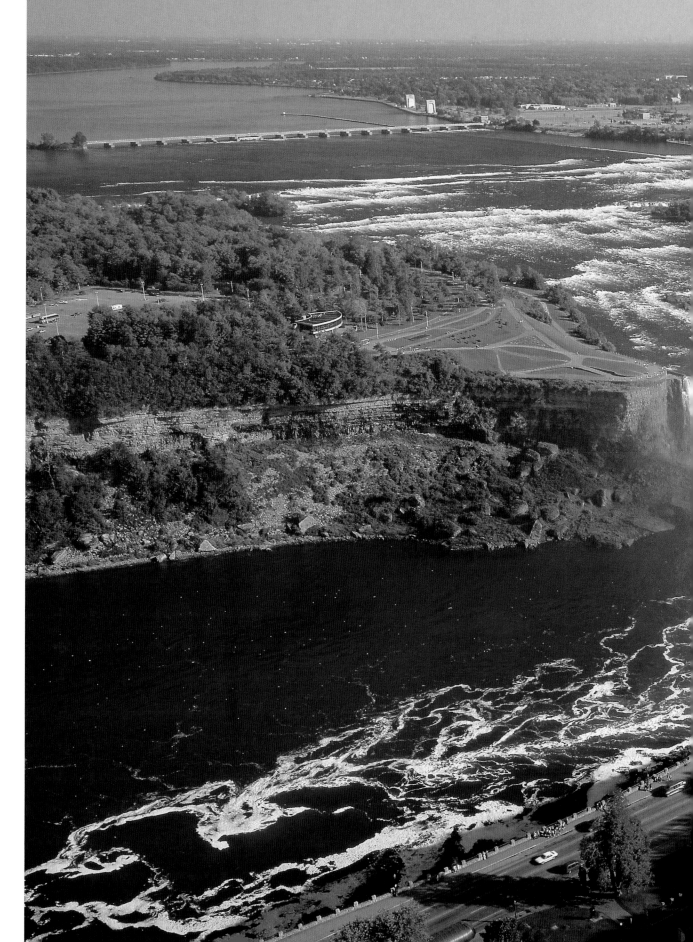

The seventh natural wonder of the world, Niagara Falls attracts more than 12 million visitors annually. Millions of litres of water cascade over the falls—so much that the cliff edge beneath the river erodes at a rate of three centimetres per year.

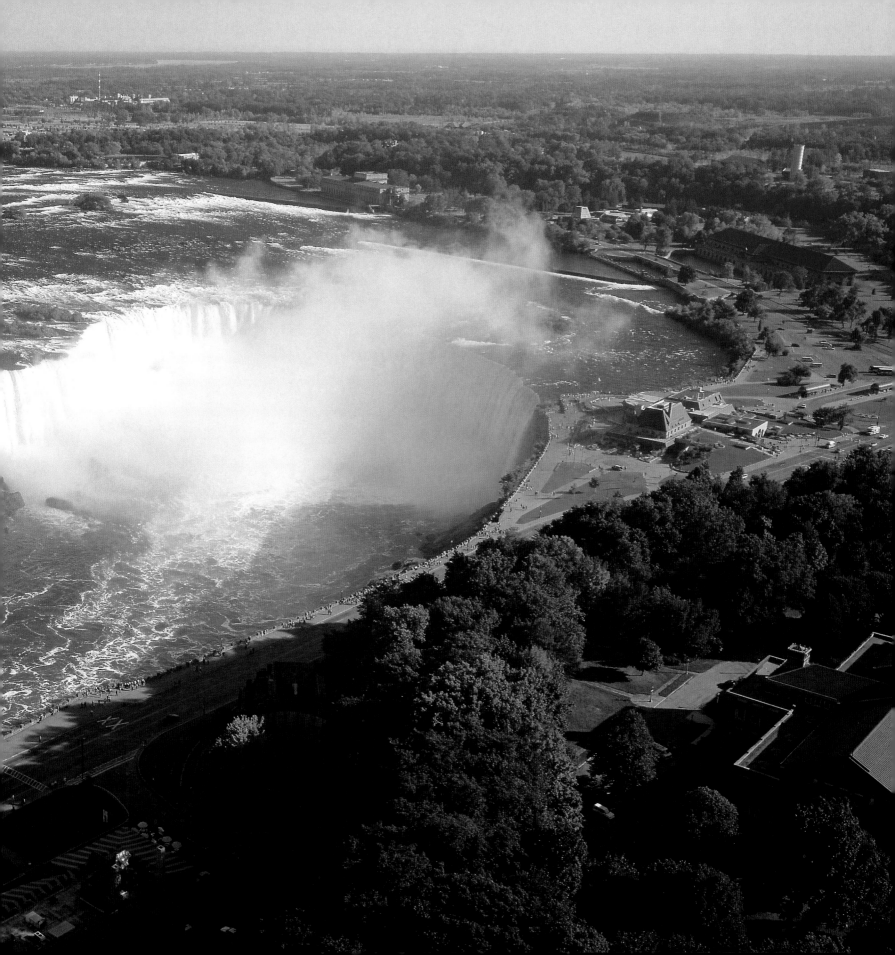

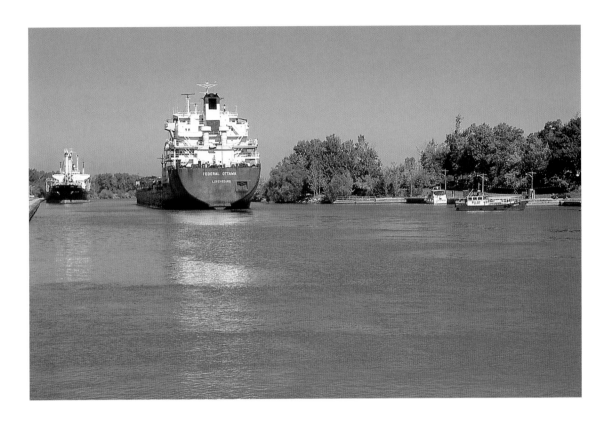

People have gone over Niagara Falls in barrels, but the preferred route from Lake Erie to Lake Ontario is the Welland Canal. Seven locks float more than 1000 ships a year down the 327-metre drop to Lake Ontario.

Since 1953, Shakespeare has come to life in Stratford, Ontario, where the first shows were held under a giant tent. The Festival Theatre replaced the tent in 1957 and today several theatres offer plays and musicals to thousands of people each summer.

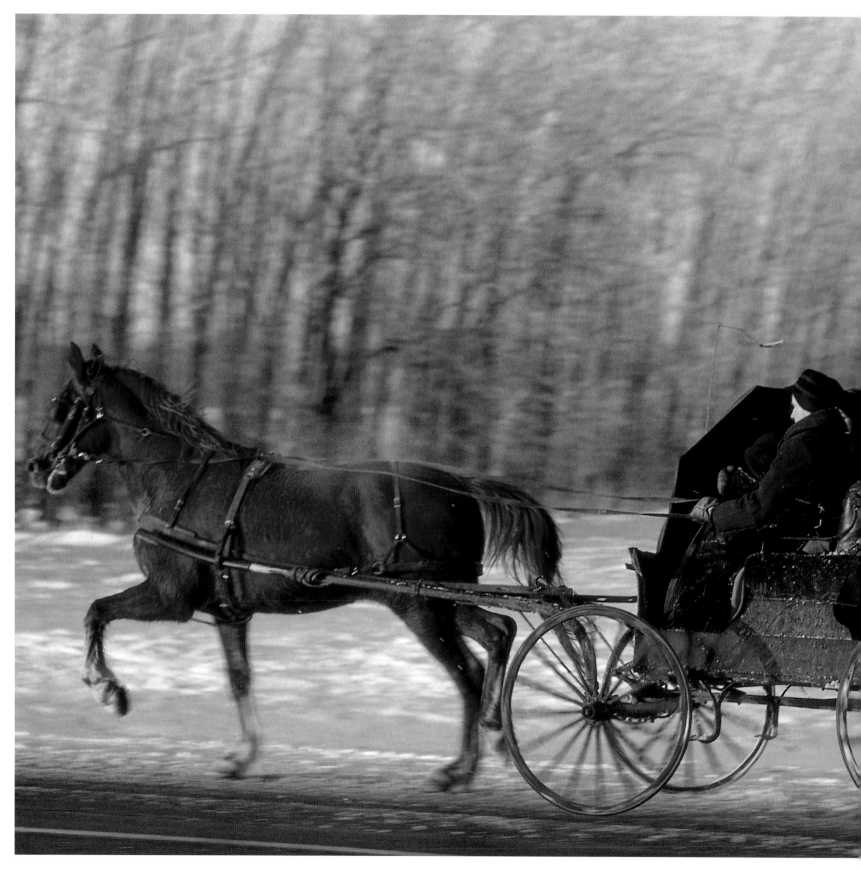

Pennsylvania Mennonites arrived in the area between Kitchener and Waterloo about 1800. Some still uphold strict orthodox values, farming with traditional methods and following a peaceful and community-oriented way of life.

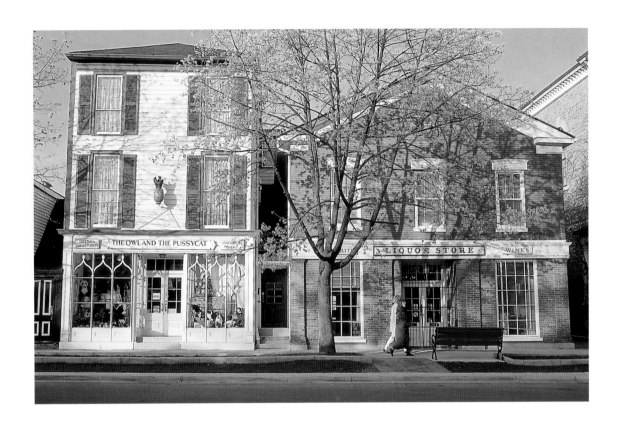

The nineteenth-century village of Niagara-on-the-Lake is home to the Shaw Festival, an annual event dedicated to the works of George Bernard Shaw and the plays, musicals, and mimes of his contemporaries.

During the War of 1812, Laura Secord ran 30 kilometres to warn British forces of an American attack. Today she is better known for the chocolate company that bears her name. The company has restored the home of this mother of seven on Partition Street in Queenston.

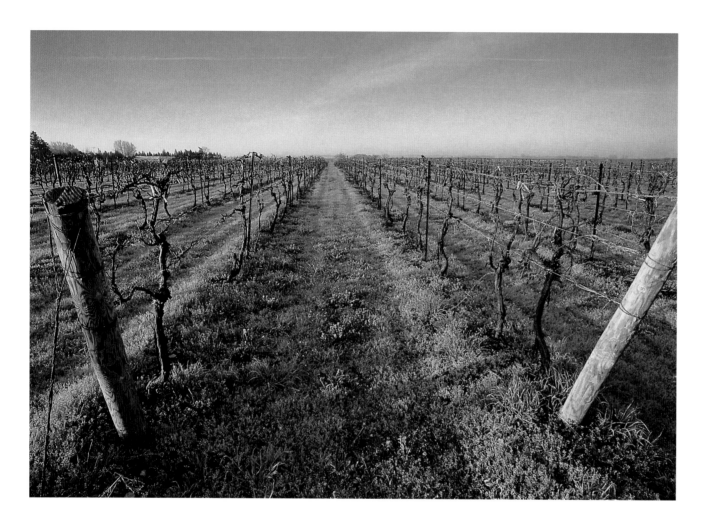

The vineyard region of the Niagara Peninsula is popular with visitors, particularly in the fall harvest season, when the nearby town of St. Catharines draws crowds to the Niagara Grape and Wine Festival.

Politician and railroad baron Sir Allan Napier MacNab lived a life of luxury in nineteenth-century Hamilton. He built Dundurn Castle between 1832 and 1835 and decorated it in elaborate Victorian style.

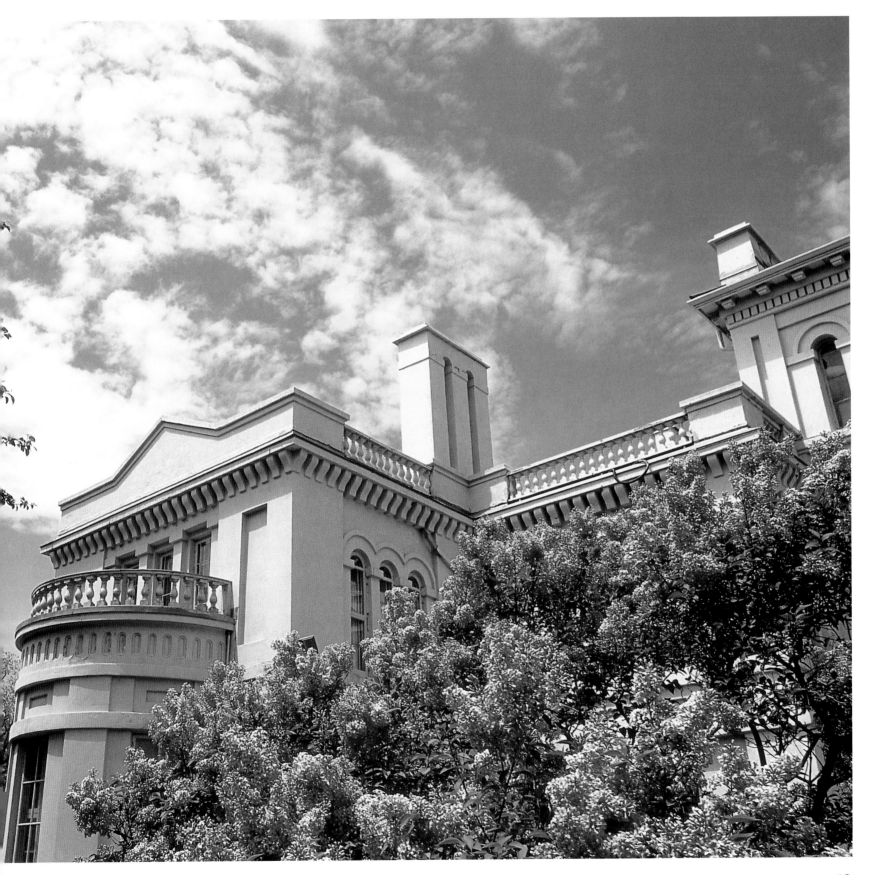

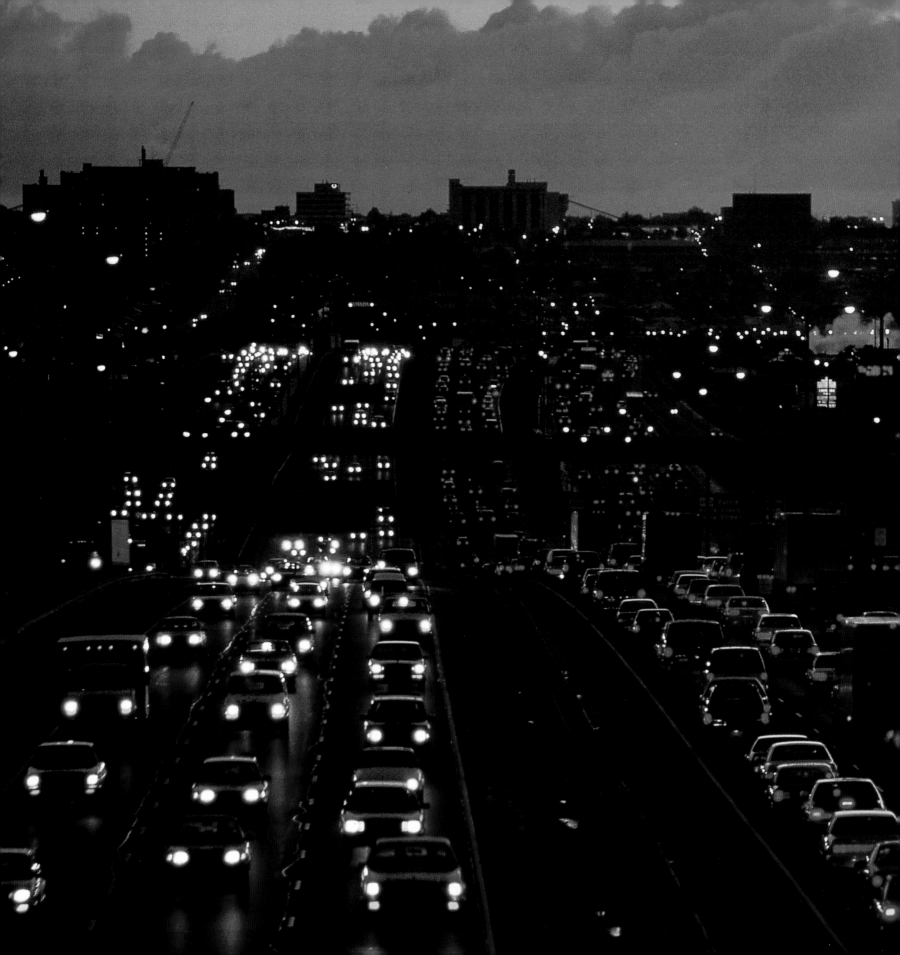

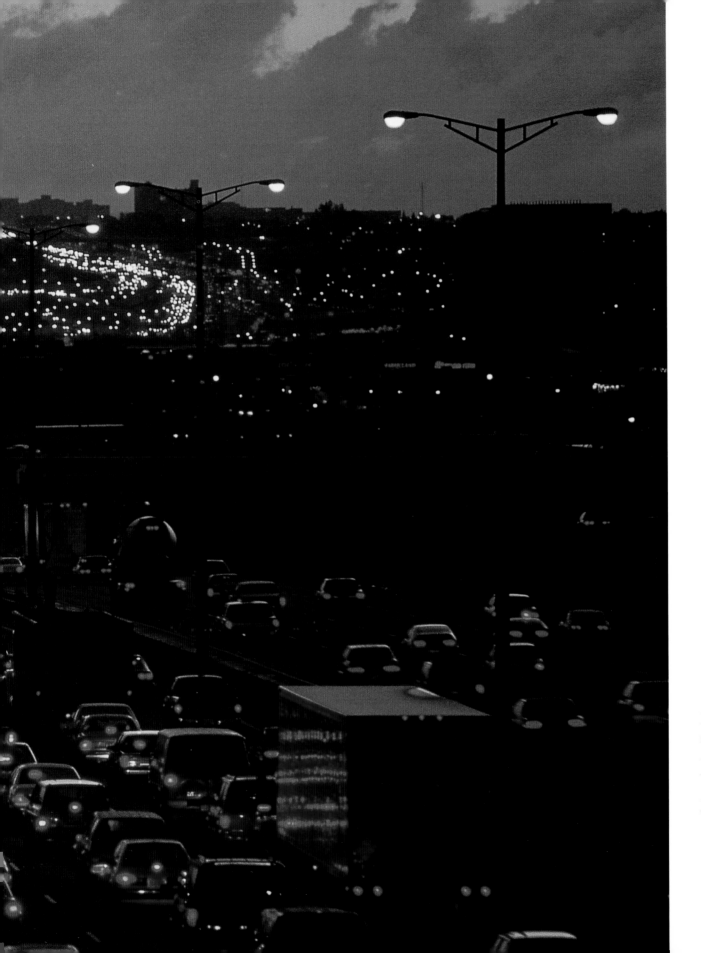

Morning commuters stream along Highway 401, the main east-west artery in the northern part of Toronto.

From paddle-boating to yachting, marinas along the shore of Lake Ontario offer a range of recreation opportunities. With 2000 hours of sunshine annually, Torontonians have plenty of time to enjoy the water.

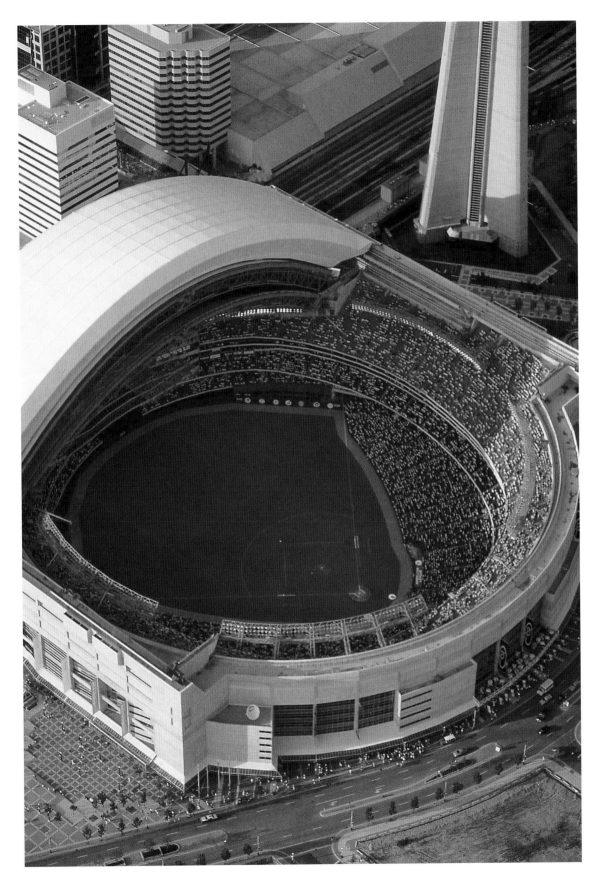

Built in 1989, the 52,000-seat SkyDome was the first sports dome in the world to have a fully retractable roof. It hosts Blue Jays baseball, Argonauts football, and Raptors basketball games.

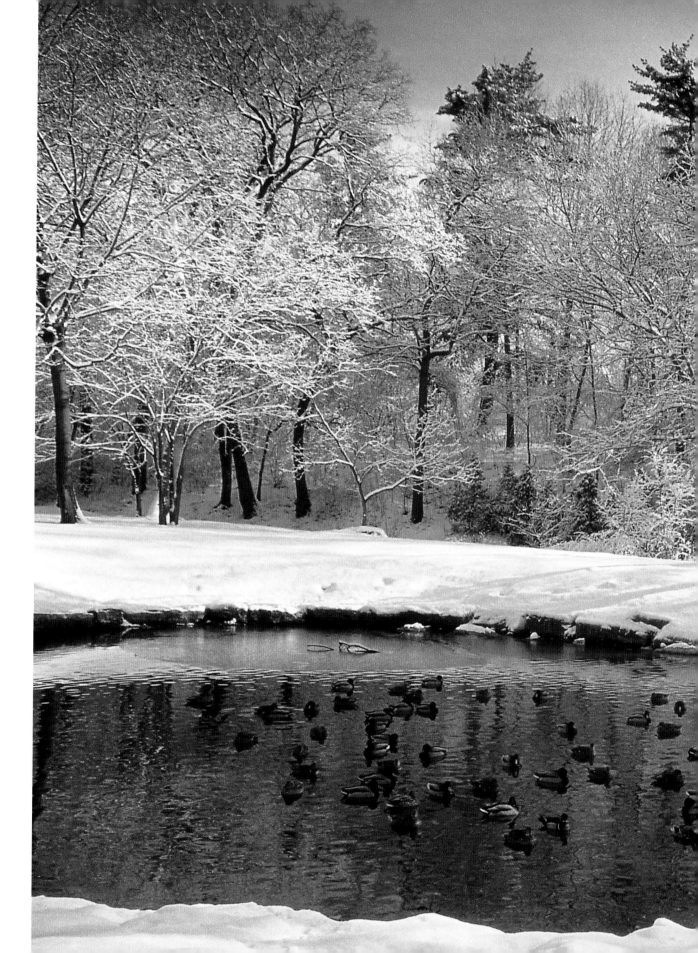

A community of ducks braves winter in High Park. Though Toronto is further south than a number of American states, average winter lows are still well below zero degrees Celsius.

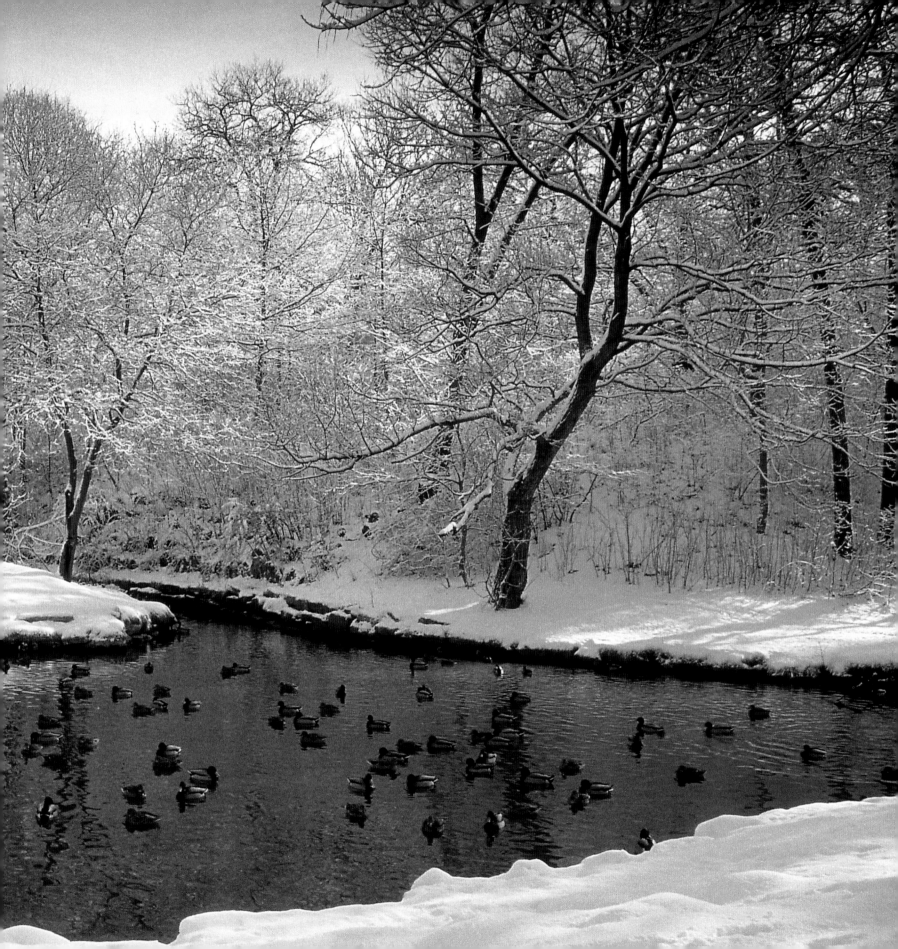

Unionville, settled by German immigrants in the late eighteenth
century, was one of the first Lutheran communities in Ontario.

Kleinburg, population 1400, is an attractive artists' community just north of Toronto. It's known for its remarkable doll museum and for the displays of Group of Seven paintings and First Nations art at the McMichael Art Gallery on the outskirts of town.

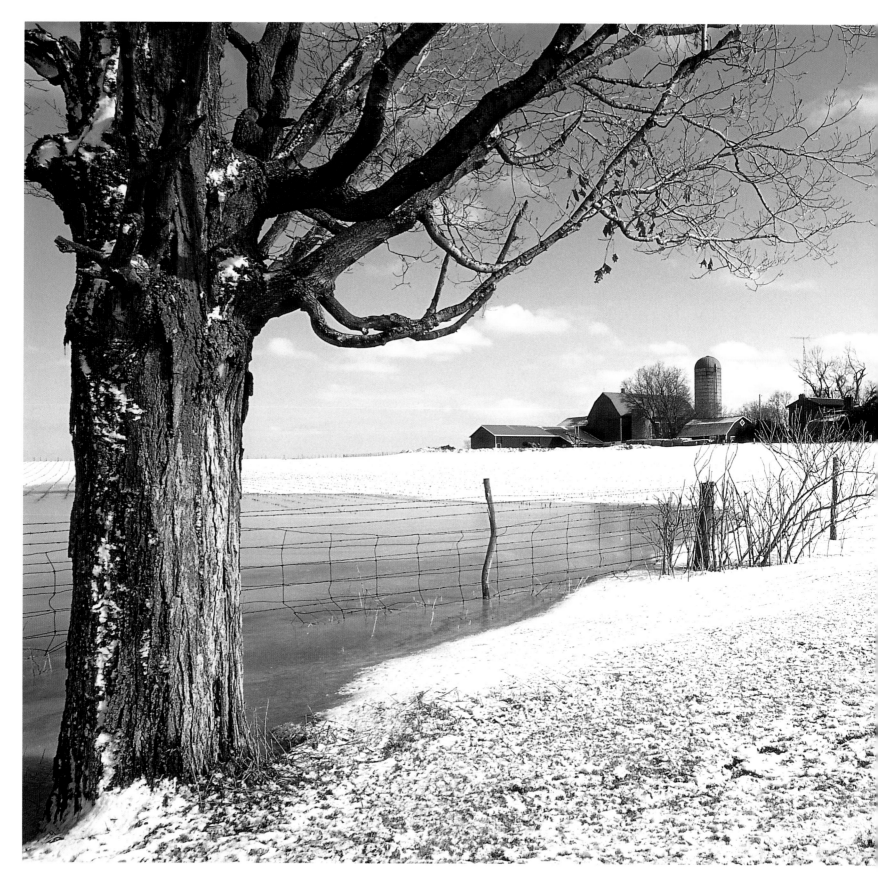

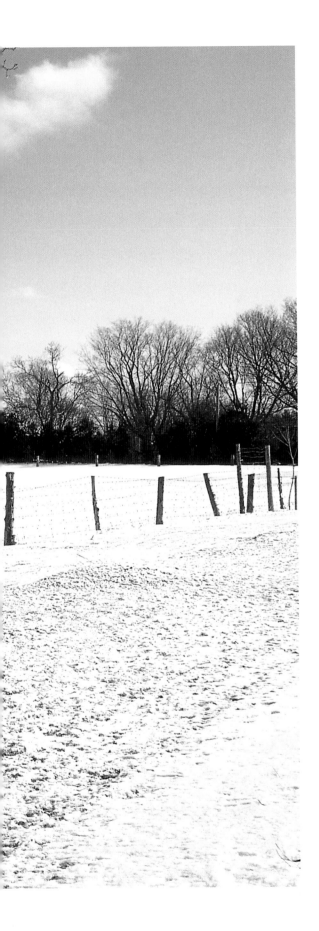

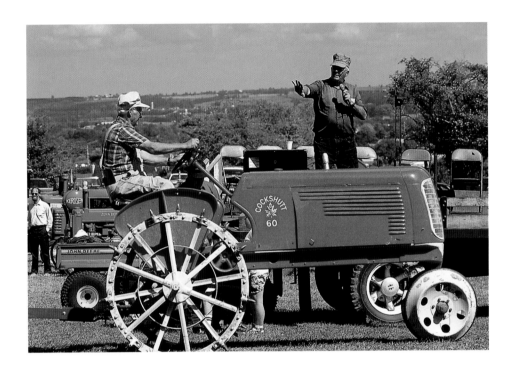

At the Steam Threshing Fair in Uxbridge, an antique tractor is on display among more modern models. The Uxbridge area was originally settled by Quaker families and remains an agricultural centre.

Snow blankets the countryside near Newmarket.

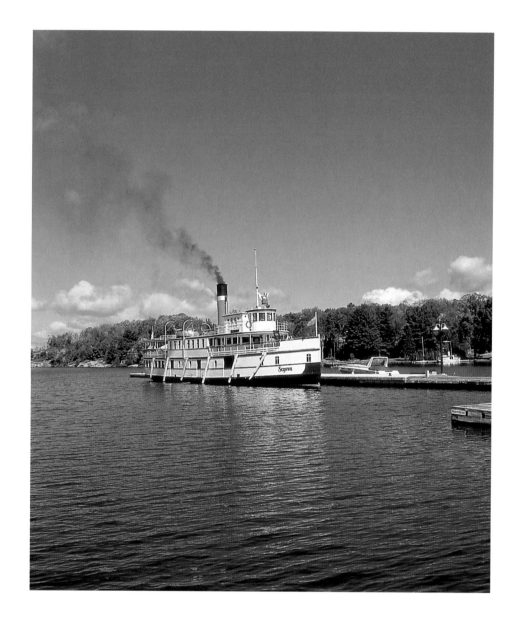

In the early 1900s, steamboats brought Ontario's rich to posh resorts on the shores of Lake Muskoka. Some of these resorts still operate, and Torontonians flock to the area for quiet summer weekends.

Politician Peter Perry planned the Port Perry townsite in 1848.

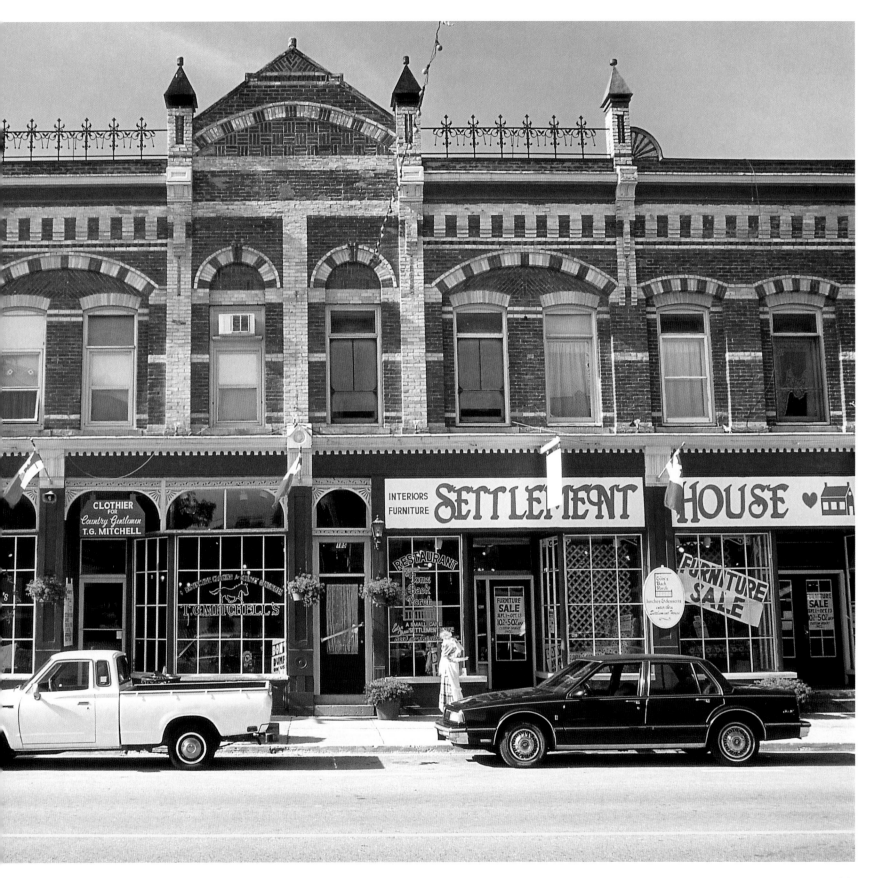

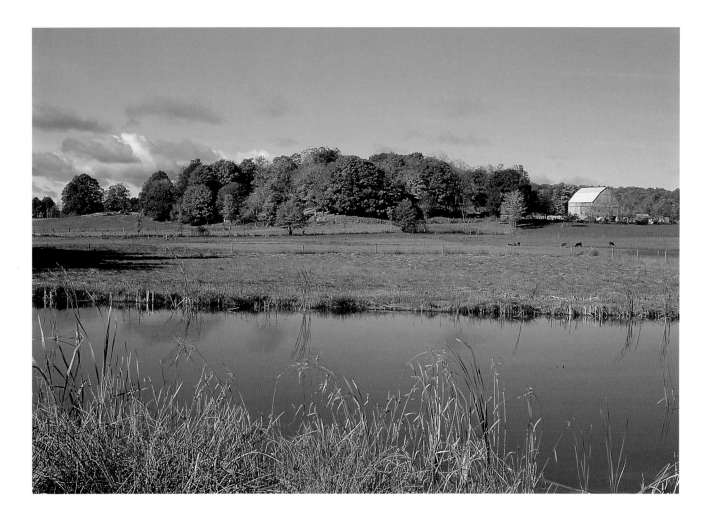

The Muskoka Lakes region, north of Toronto,
is a centre for agriculture and recreation.

Stephen Leacock began as a
lecturer and academic – one of his
political science textbooks was
published in 17 languages. However,
it is his warm and witty satire of
small-town life in books such as
Sunshine Sketches of a Little Town that
continues to draw fans to his home
in Orillia.

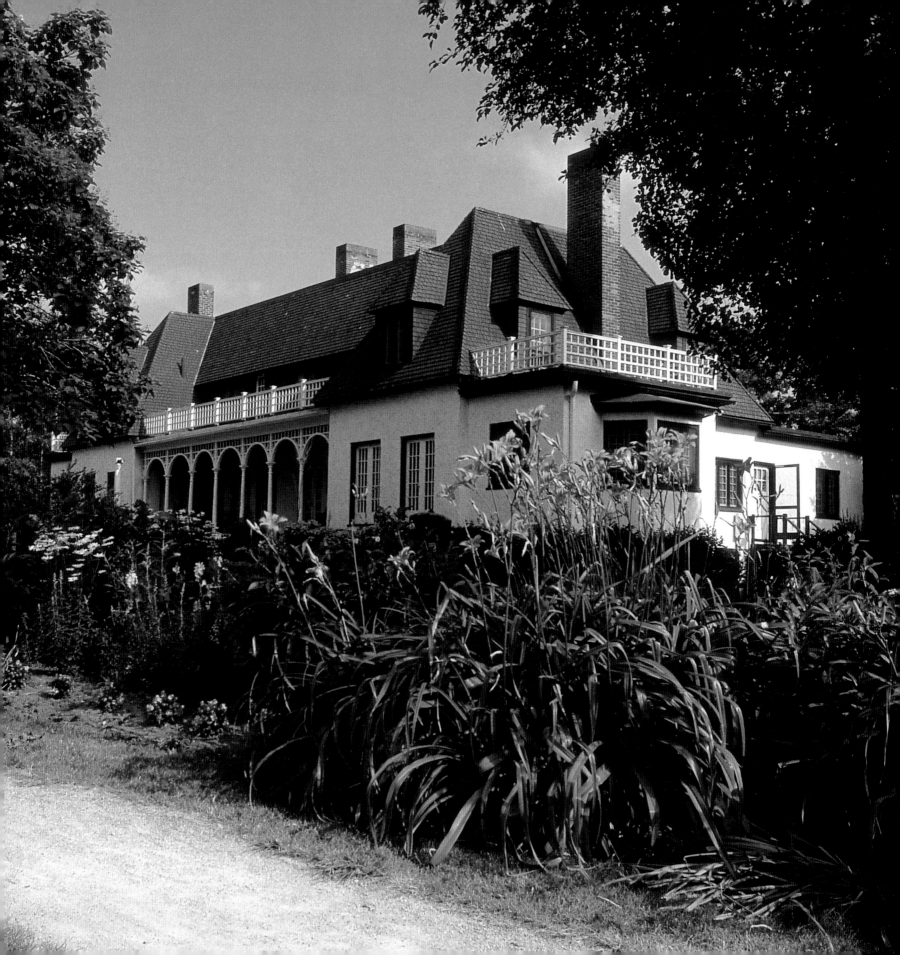

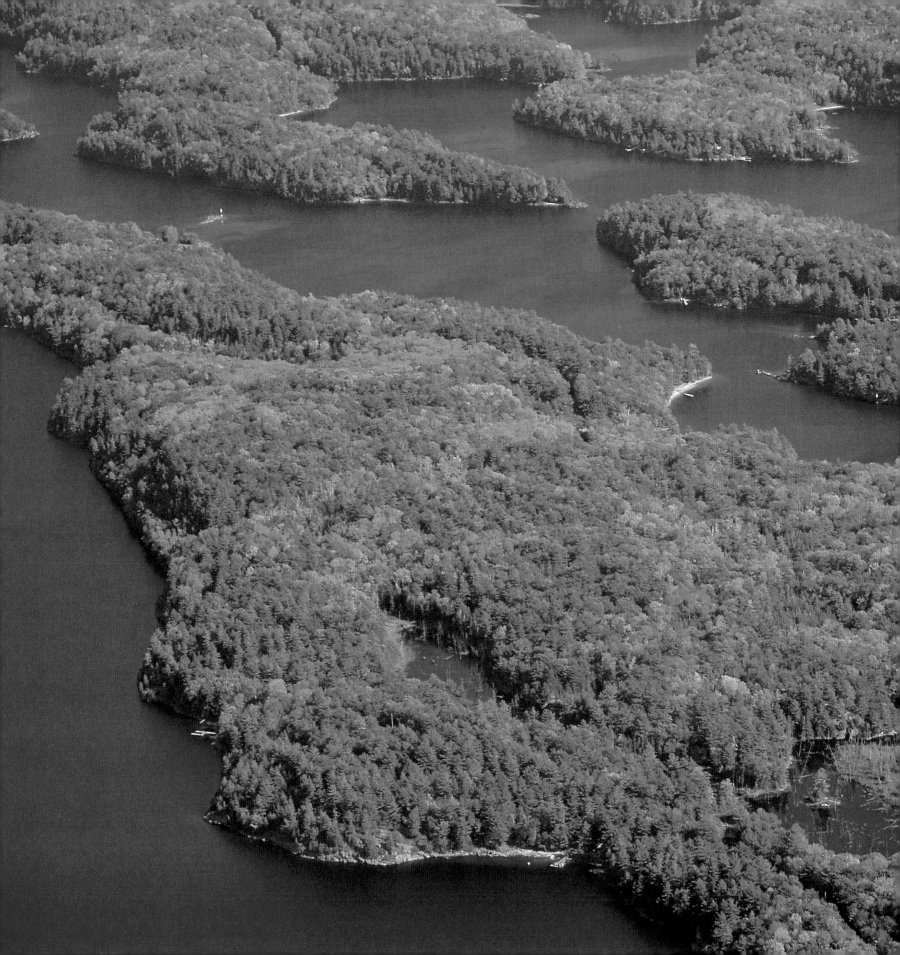

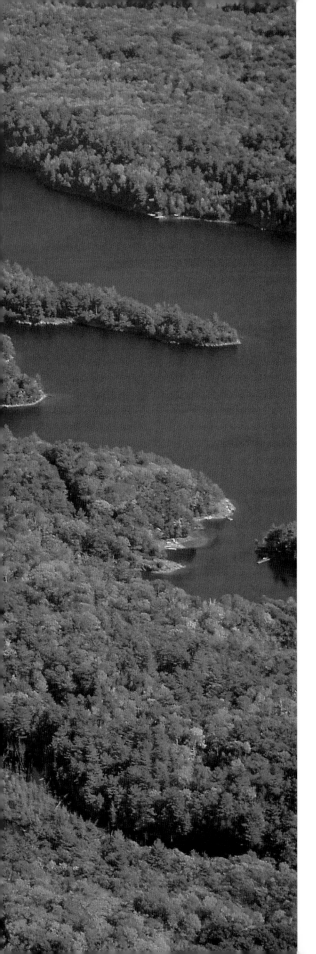

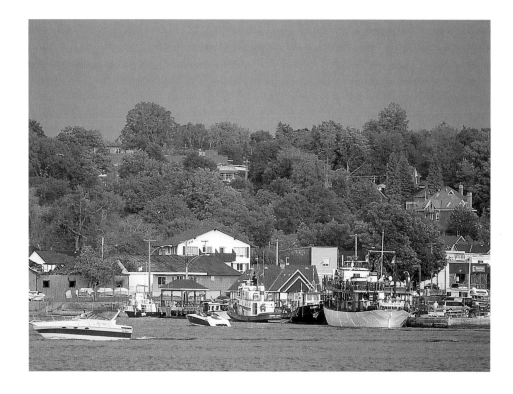

Penetanguishene, on the shores of Georgian Bay, began as a navy base in the early 1800s. Now that relations with the Americans are more friendly, the docks are lined with pleasure boats.

Some 30,000 islands are scattered in Georgian Bay. Many are privately owned, but 59 are protected by Georgian Bay Islands National Park and are popular with boaters, swimmers, and divers.

OVERLEAF –
A historic farmhouse perches on Long Point on the shores of Lake Erie. Much of the point is a protected bird sanctuary that attracts more than 100 species.

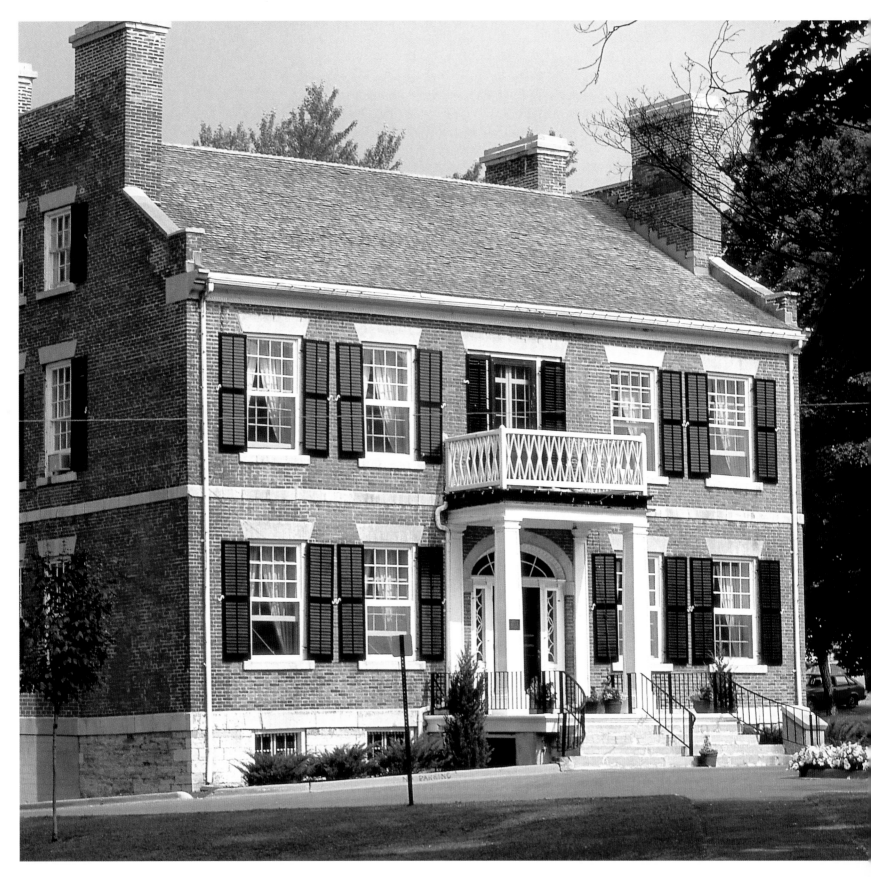

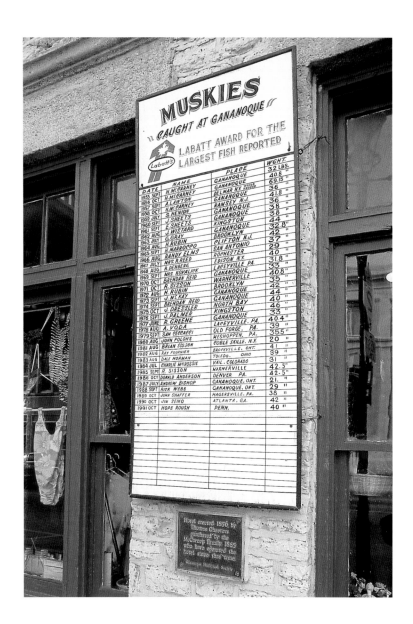

MUSKIES CAUGHT AT GANANOQUE

LABATT AWARD FOR THE LARGEST FISH REPORTED

DATE	NAME	PLACE	WGHT.
		GANANOQUE	32 LBS.
1955 SEPT	H. McCARNEY	GANANOQUE	40.8"
1956 OCT	H. McCARNEY	DELMAR NY	69.15"
1957 SEPT	A. LAWTON	GANANOQUE	36"
1958 OCT	H. McCARNEY	RAMSEY N.J.	41.8"
1959 JULY	S. HENION	GANANOQUE	36"
1960 SEPT	J. SHEETS	GANANOQUE	38"
1961 SEPT	E. SHEETS	KINGSTON	44"
1962 AUG	J. WISTARD	GANANOQUE	32.8"
1963 JULY	G. GRAY	BROOKLYN	42"
1964 AUG	H. RUBIN	CLIFTON N.J.	37"
1965 SEPT	H. MARROCCO	SAN ANTONIO	29"
1966 AUG	RANDY ELMS	ROCHESTER	40"
1967 JULY	MRS. R. REED	EDISON N.Y.	31.8"
1968 AUG	R. DENBERG	LACEYVILLE PA.	33"
1969 SEPT	MRS. KOVALICK	GANANOQUE	40.8"
1970 OCT	BRENDAN REID	WARNERVILLE	35"
1971 OCT	R. SISSON	BROOKLYN	42"
1972 AUG	H. RUBIN	GANANOQUE	44"
1973 SEPT	J. McKAY	GANANOQUE	40"
1974 SEPT	BRENDAN REID	NORTH BAY	46"
1975 OCT	J. DRESSLER	KINGSTON	33"
1976 SEPT	J. PALMER	GANANOQUE	40.4"
1977 JUNE	R. GREENE	LACEYVILLE, PA.	39"
1978 AUG	A. VODA	OLD FORGE, PA.	55.5"
1979 SEPT	SAN CECCACCI	MESHOPPEN, PA.	20"
1980 AUG	JOHN POLONS	COBLE SKILE, N.Y.	41"
1981 AUG	BRIAN SISSON	BROCKVILLE, ONT.	39"
1982 AUG	RAY FOURNIER	TOLEDO, OHIO	31"
1983 AUG	DALE NORMAN	VAIL, COLORADO	42.5"
1984 JUL	CHARLIE McROSSIE	WARNERVILLE	42.5"
1985 SEPT	R. SISSON	DENVER PA.	21"
1986 OCT	DONALD ANDERSON	GANANOQUE, ONT.	29"
1987 JULY	ANDREW BISHOP	GANANOQUE, ONT.	38"
1988 SEPT	RICK WEBB	HAGERSVILLE. PA.	42"
1989 OCT	JOHN SHAFFER	ATLANTA. GA.	40"
1990 OCT	JIM SEIKO	PENN.	
1991 OCT	HOPE ROUSH	PENN.	

Hotel erected 1850 by Thomas Cheevers purchased by the McCarney family 1855 who have operated the hotel since that time.
Gananoque Historical Society

A sign on a Gananoque Street records the largest fish (or fish stories) that locals have pulled from the St. Lawrence River.

The town of Gananoque had more than 50 different spellings until a post office opened in 1817 and settled the question. The restored nineteenth-century home of Charles McDonald, who once owned the province's largest flour mill, now serves as the town hall.

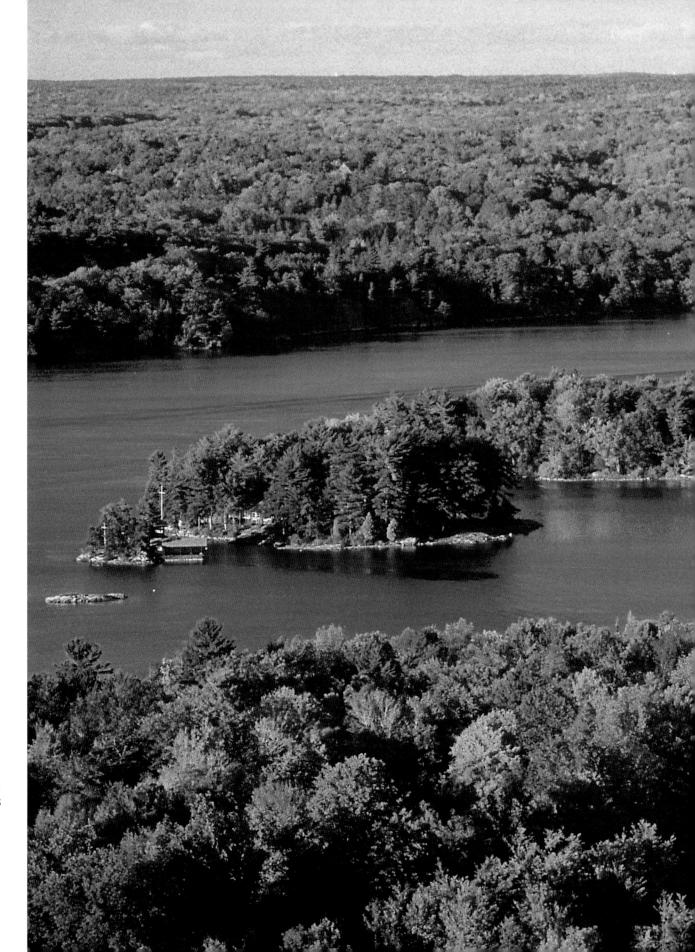

The Thousand Islands span the St. Lawrence River between Canada and the United States. There are actually more than 1800 islands, some only a few metres across and others large enough for a dock and waterfront home.

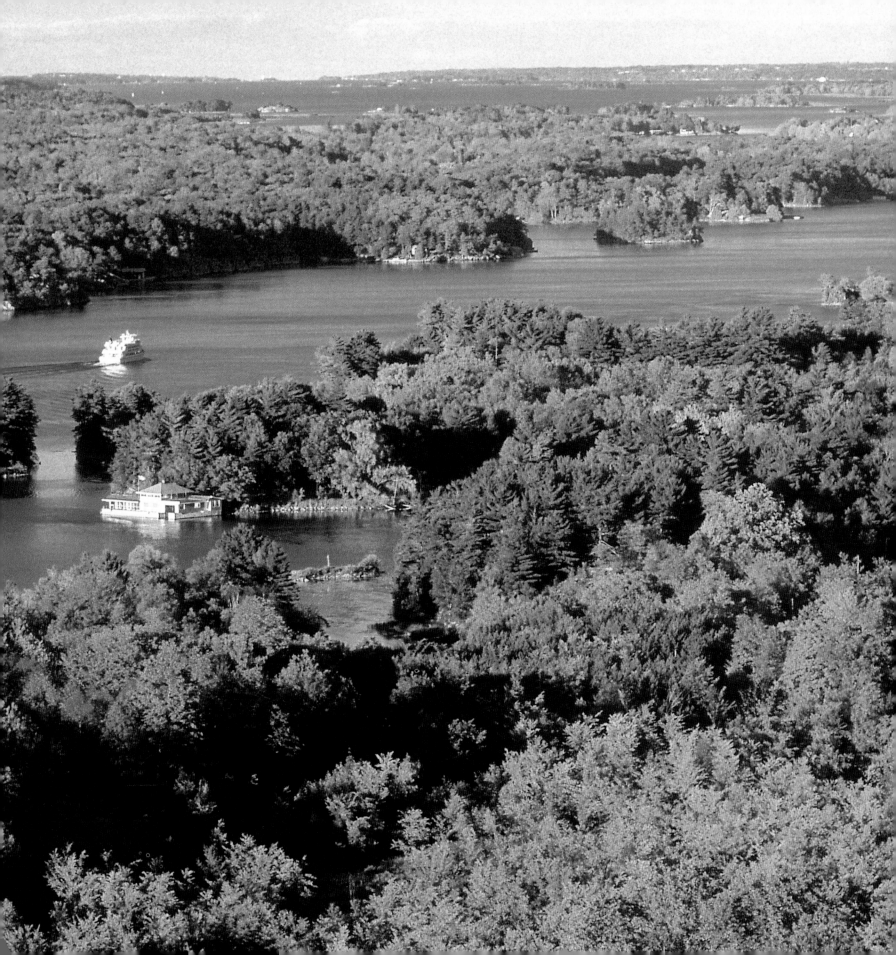

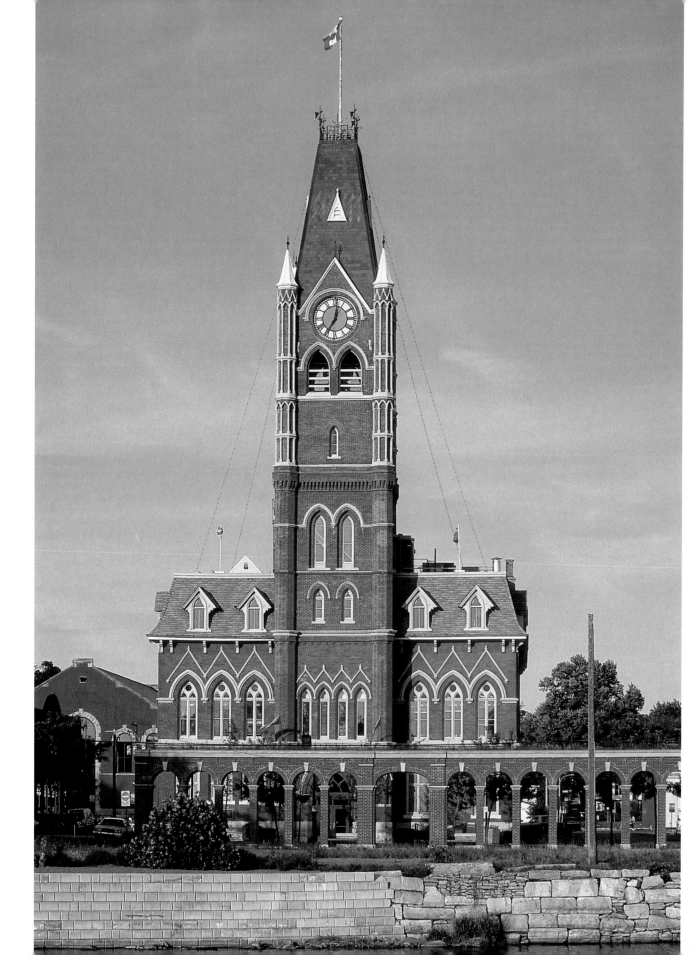

The British heritage of Belleville settlers is obvious in the town hall, a High Victorian-style structure built in the 1870s. The town is also the site of Upper Canada's first brick house, erected in 1794.

An array of colours transforms Ontario forests each fall. This bright scene at South River, east of Algonquin Povincial Park, is just a small part of the province's 800,000 square kilometres of forested land.

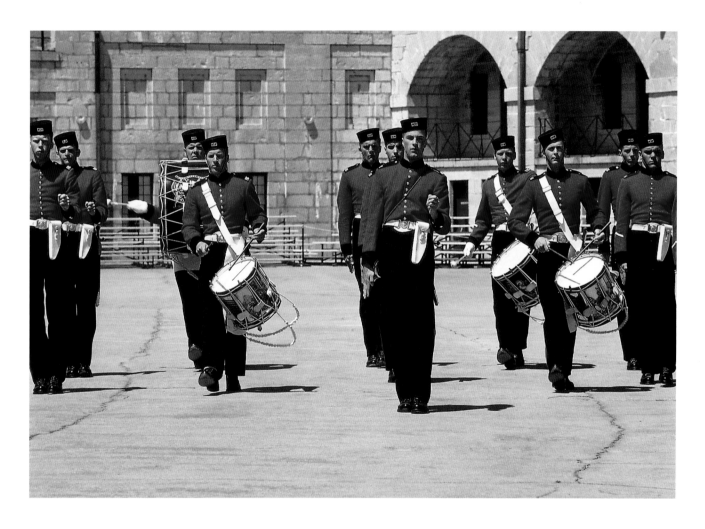

Troops in Fort Henry still march under the Union Jack. Towering above Kingston, the fort is a restoration of a British stronghold from the War of 1812.

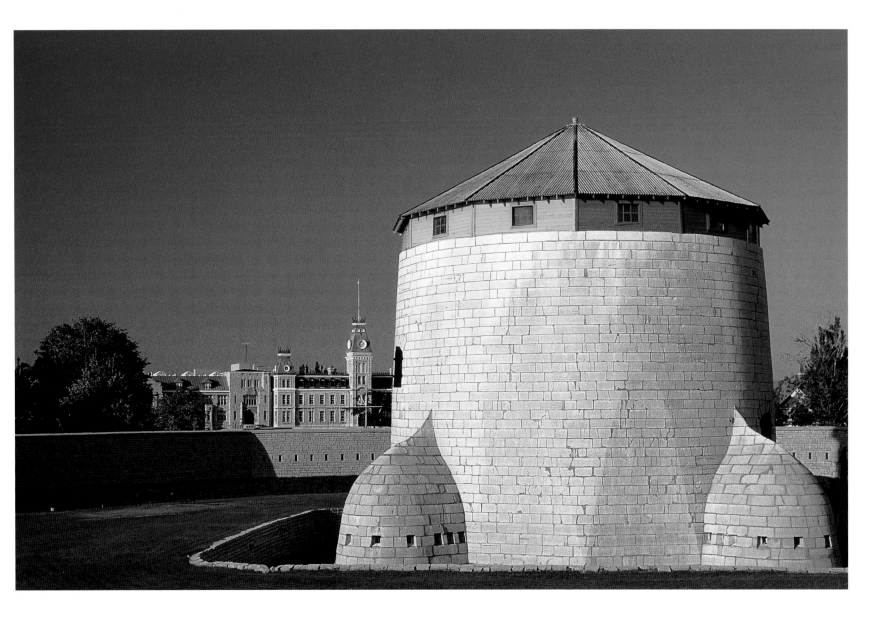

Filled with displays on the region's miliary past and the history of Kingston's Royal Military College, this Martello tower is one of the college's most interesting structures.

Dawn lights the waters of North Pine Lake in the Haliburton Highlands south of Algonquin Provincial Park.

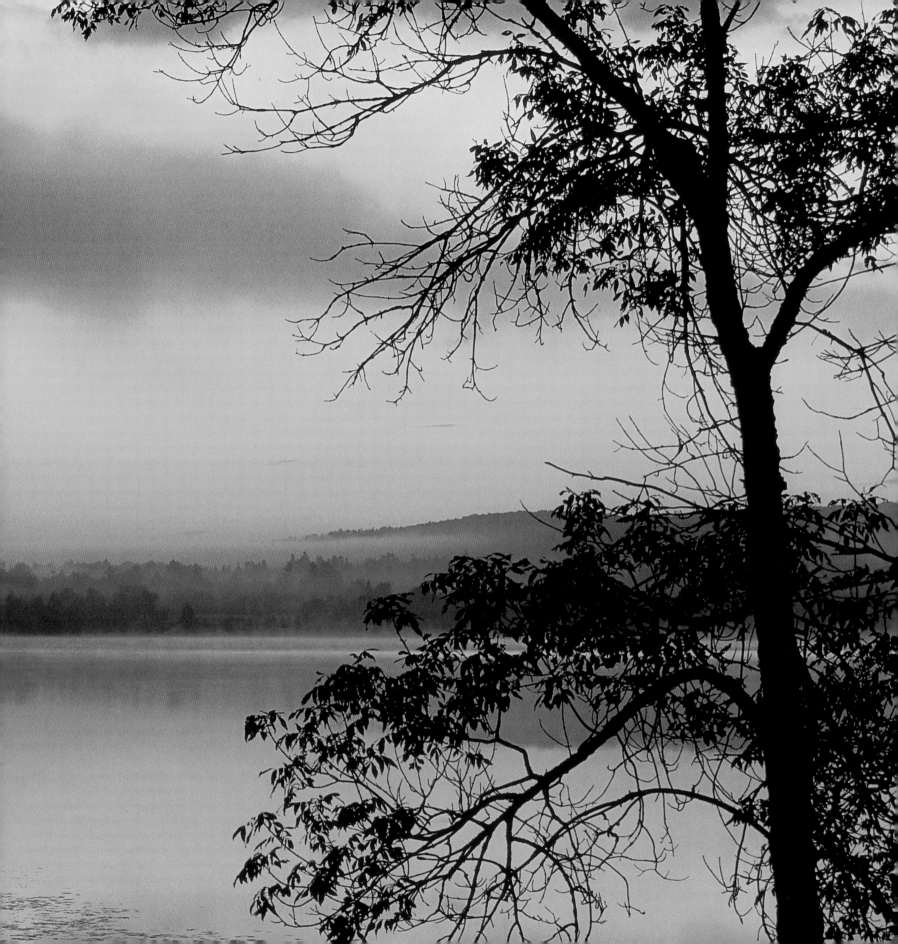

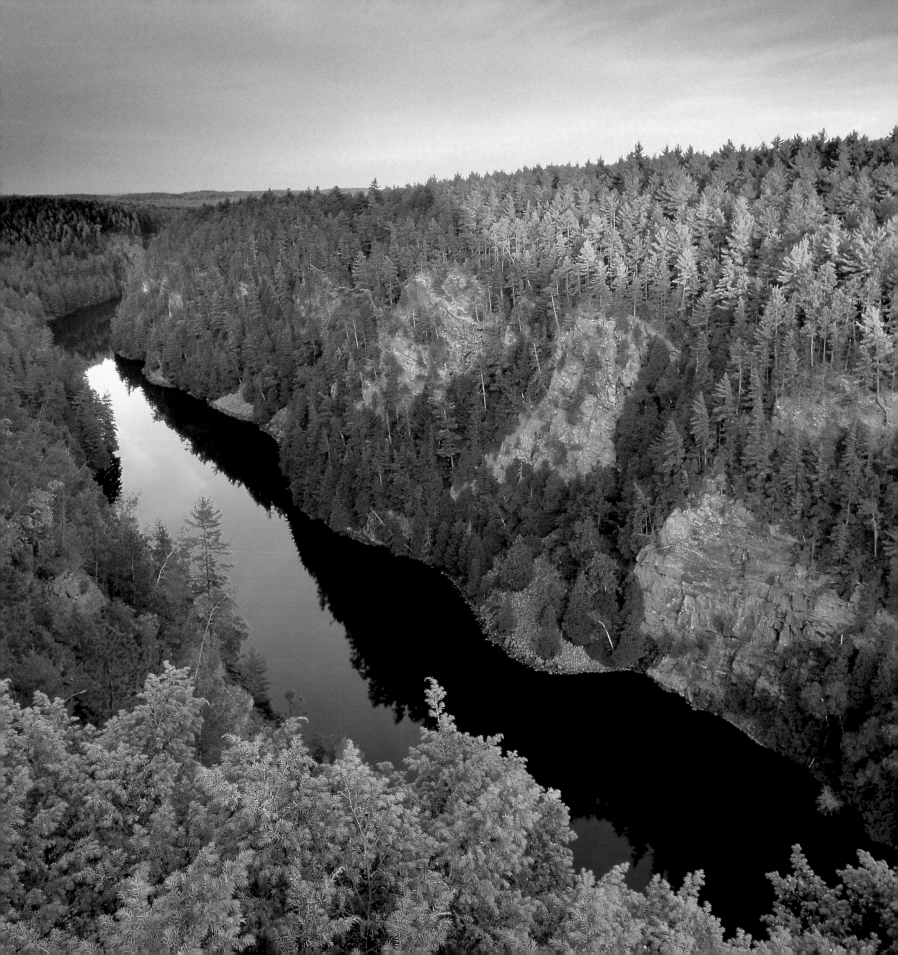

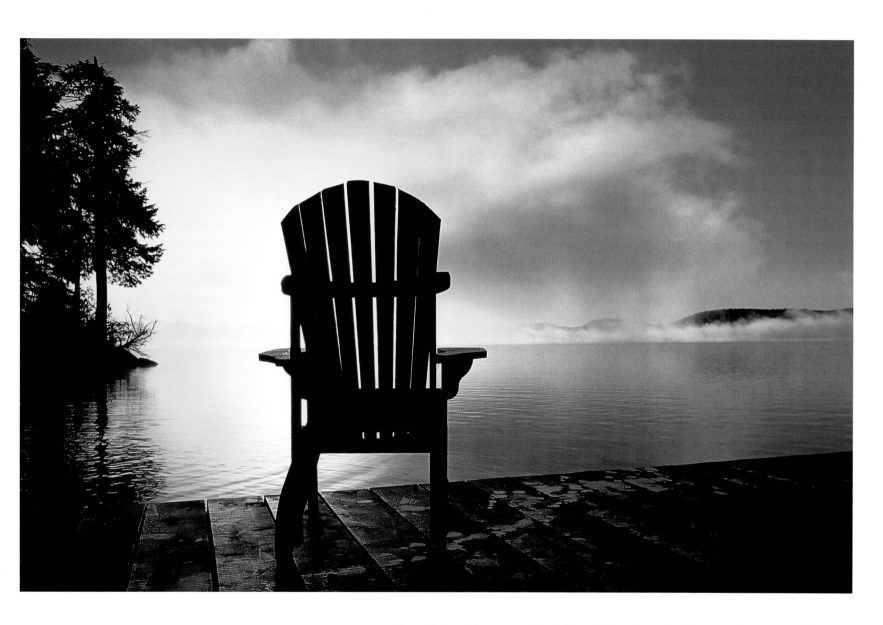

Canada's oldest provincial park has inspired nature lovers and weekend visitors since its creation in 1893. Algonquin Provincial Park was a favourite setting for Canadian painter Tom Thompson, who died in a mysterious canoe accident here in 1917.

A fault in the rock created Barron Canyon and exposed rare minerals along the cliffs. These minerals support an unusual variety of plant life.

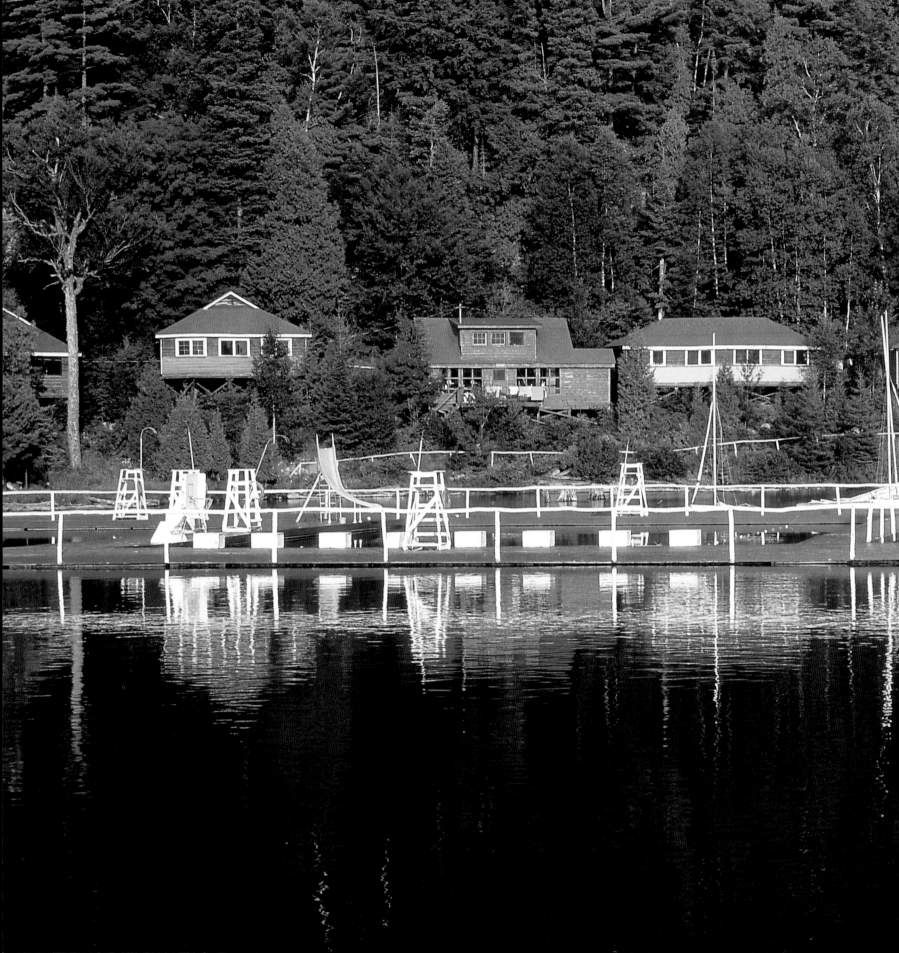

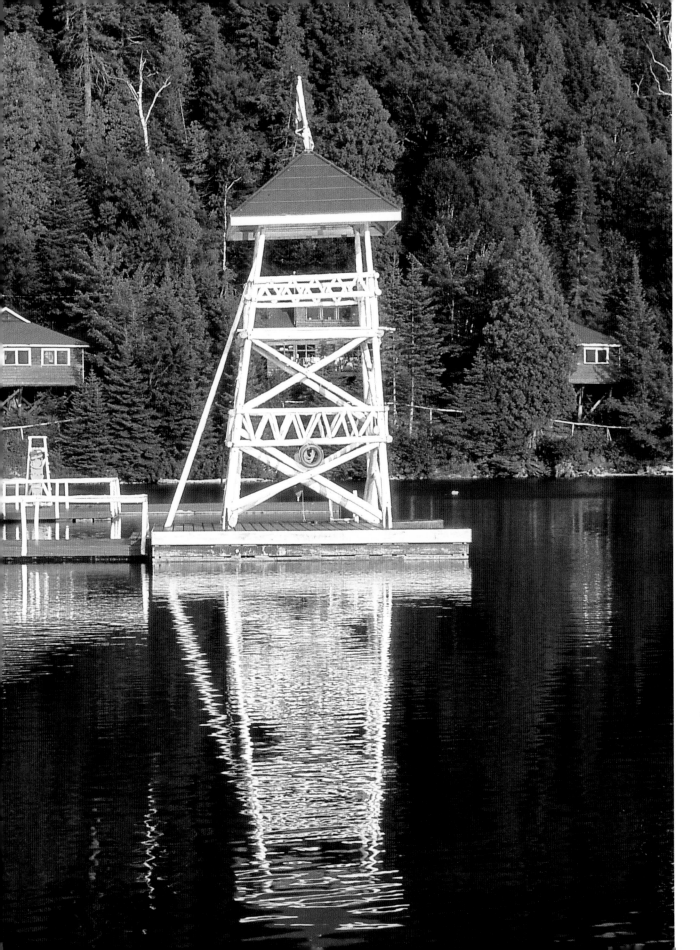

Children from Ontario's urban centres flock to camps in Algonquin Provincial Park each summer.

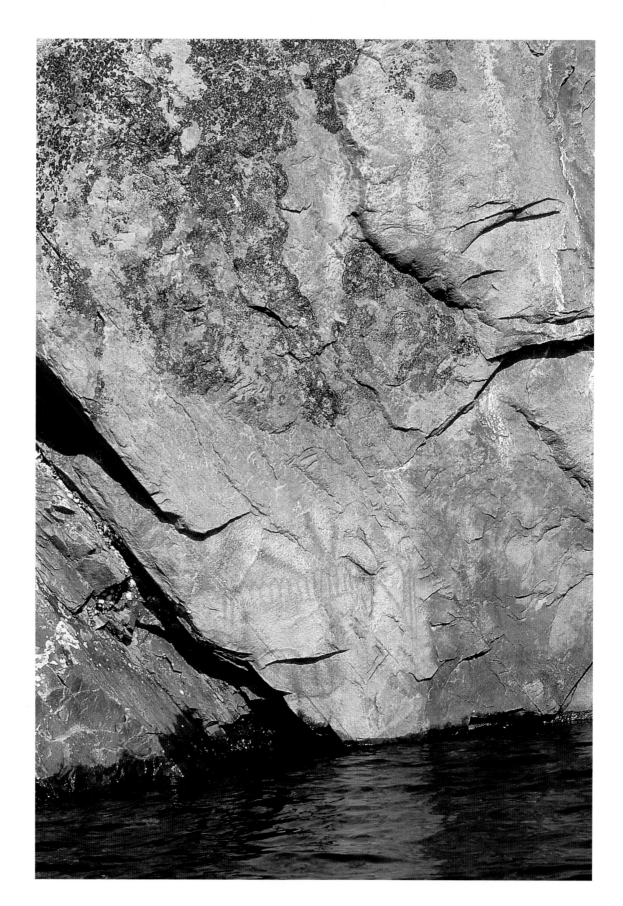

Native rock paintings, or pictographs, adorn the granite cliffs of Mazinaw Lake at Bon Echo Provincial Park.

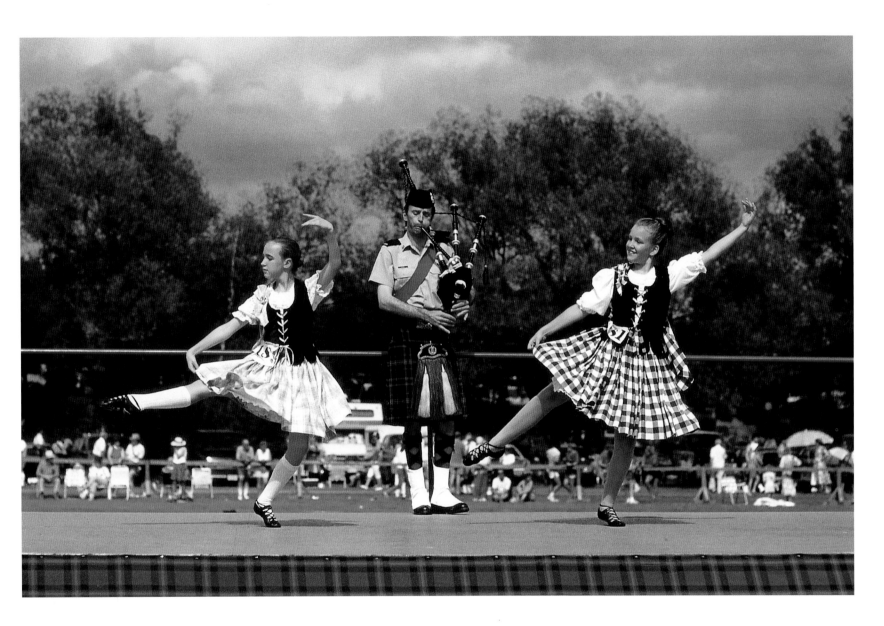

A bagpiper and dancers perform at the Highland Games in Almonte. The town is also known for a more North American pastime—this was once home to Dr. James Naismith, the inventor of basketball.

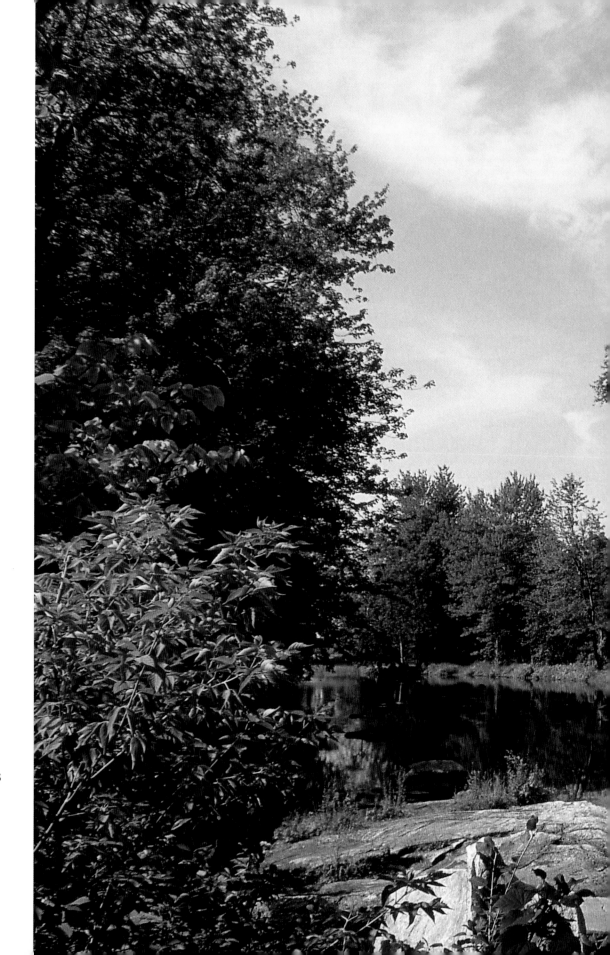

It looks quiet, but you never know what could happen in Perth. Residents made the world's largest cheese in 1892, and two law students fought Canada's last fatal duel here in 1833.

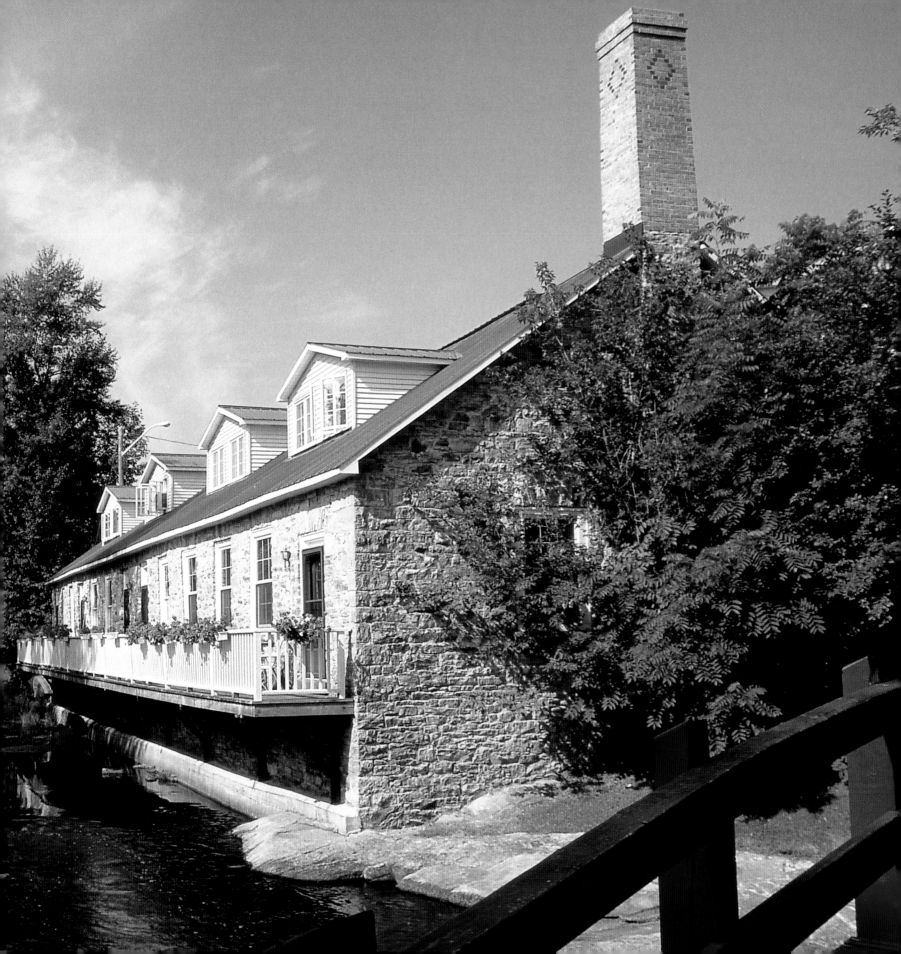

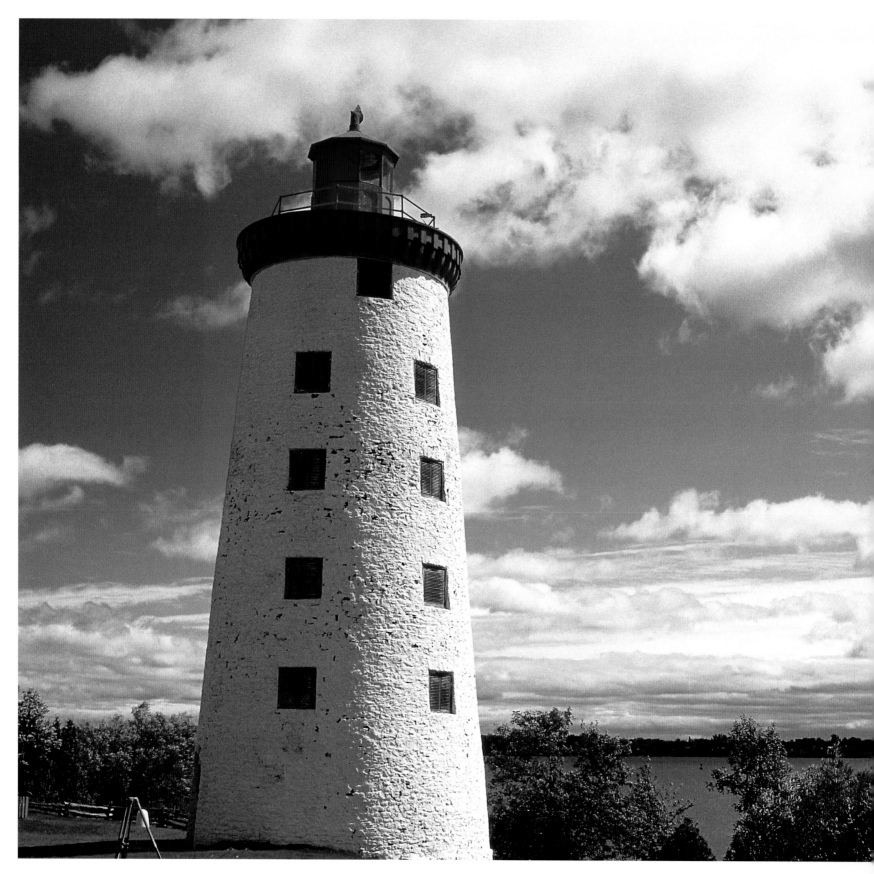

A blacksmith's shop, woolen mill, and bakery resurrect the sounds and smells of pioneer life at Upper Canada Village. About 40 buildings, accurately built in 1860s style, transport visitors to the past.

In 1838, a troop of 200 Americans determined to free Canada from British rule marched across the border and occupied this lighthouse near Prescott. They were soon ousted by British soldiers.

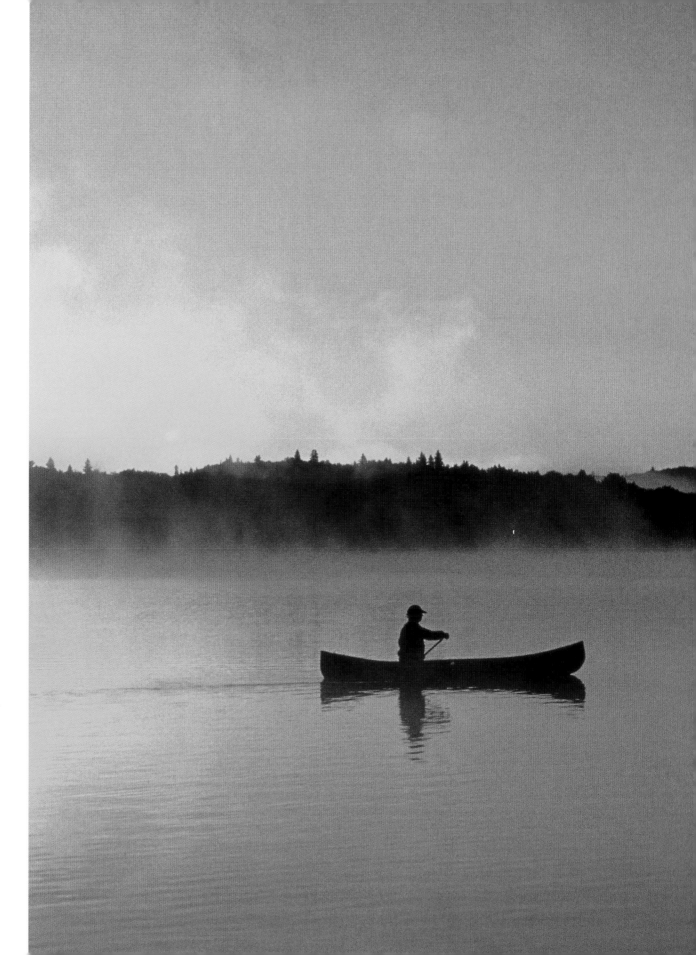

The waterways frequented by today's canoeists were once vital trading routes for the area's First Nations people.

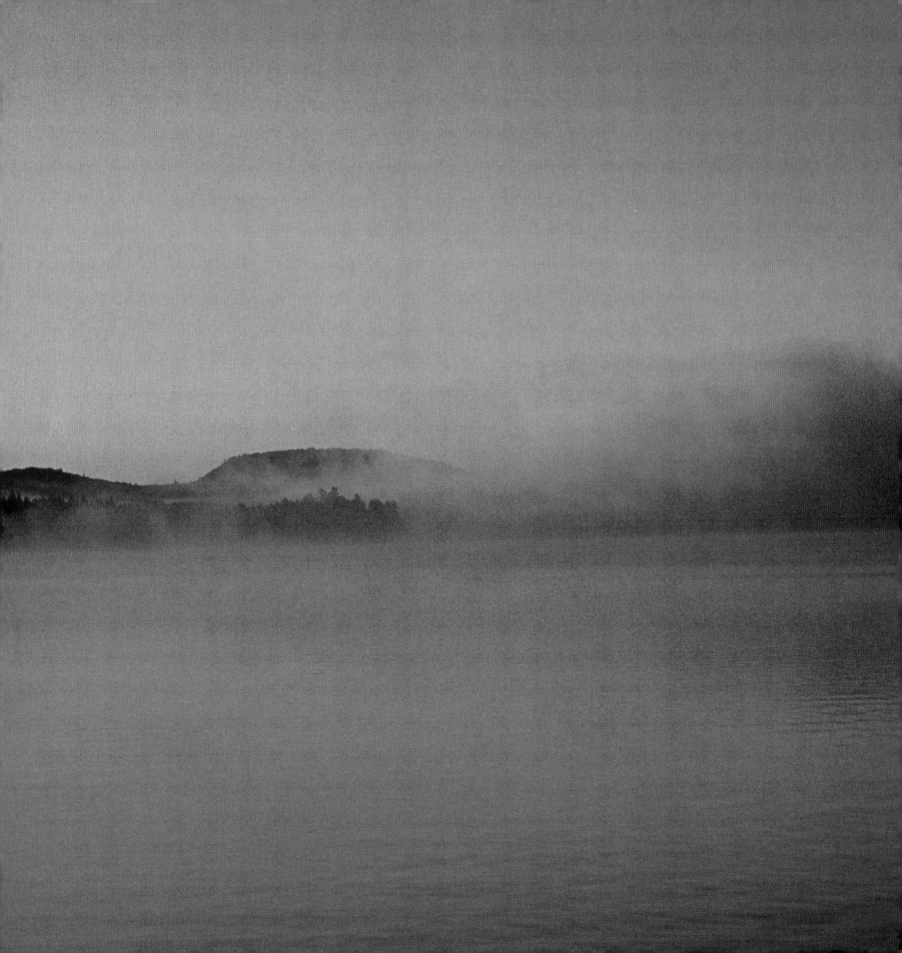

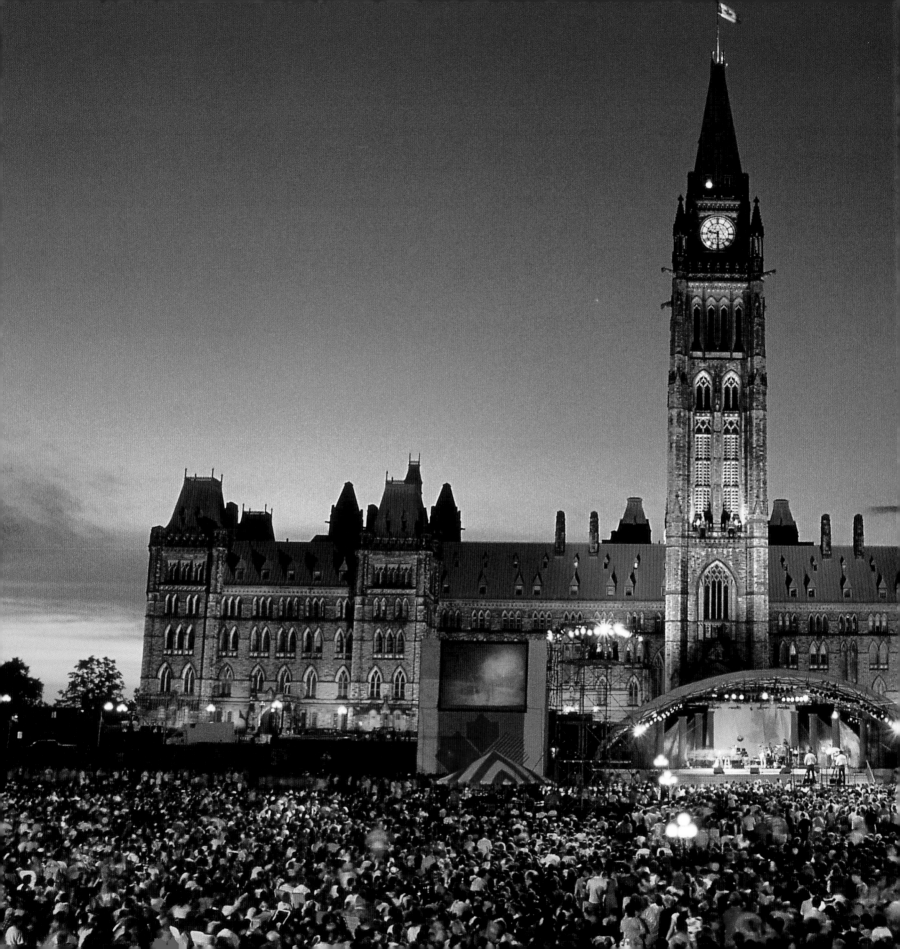

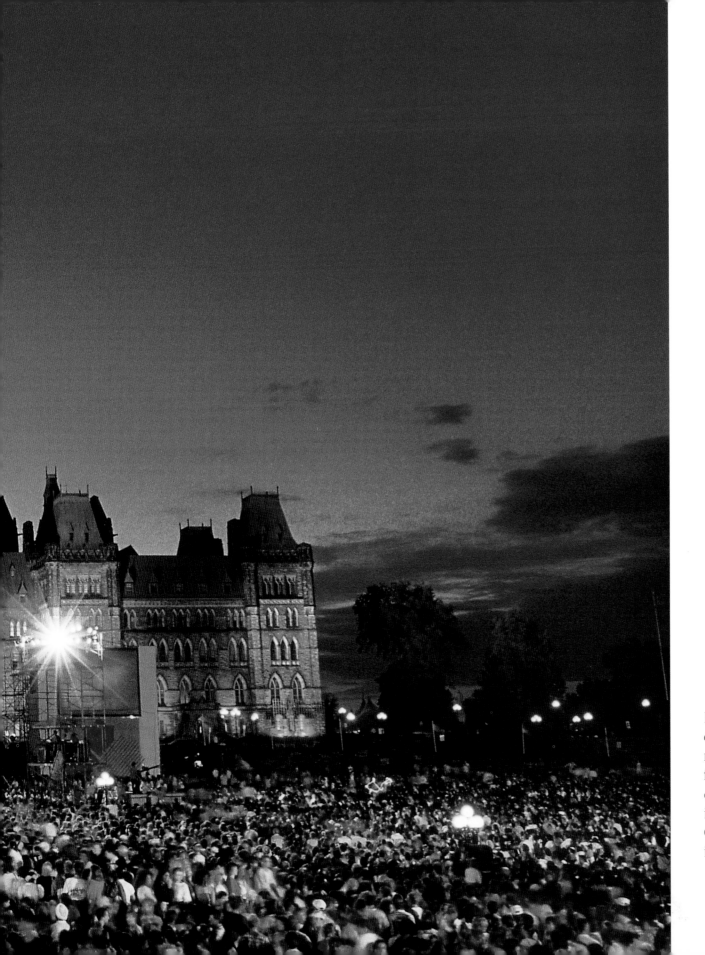

From the Changing of the Guard in the morning to music and fireworks well after dark, Parliament Hill is the centre of Canada Day activities in Ottawa.

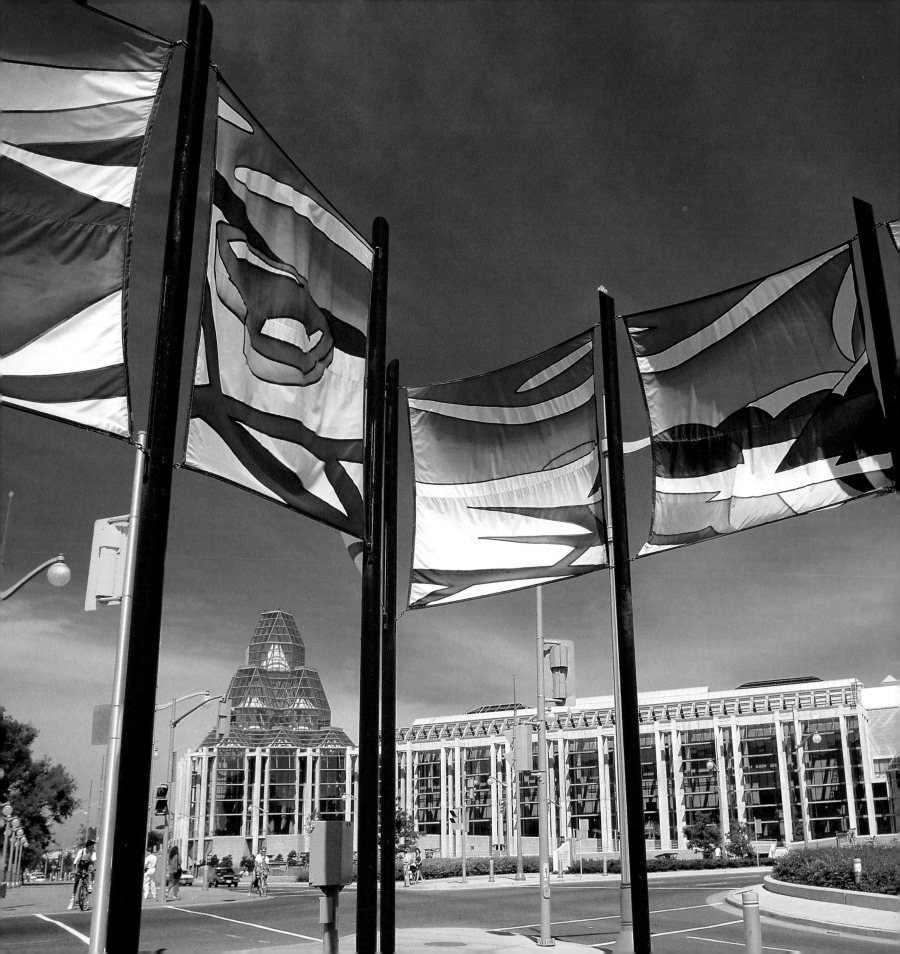

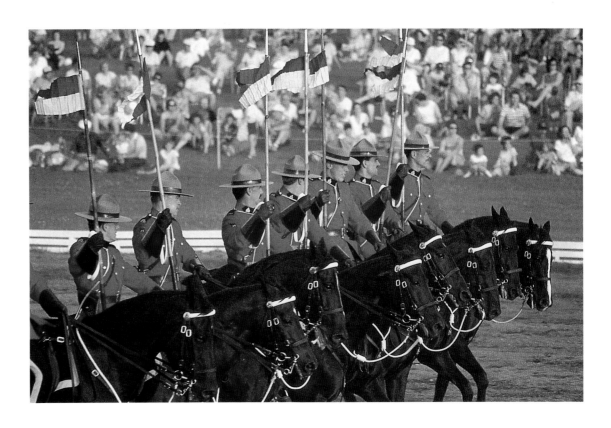

The Royal Canadian Mounted Police Musical Ride stemmed from the drill training of the police force in the nineteenth century. The Mounties perform in Ottawa each evening during the week before Canada Day.

The National Gallery was designed in 1988 by Moshe Safdie, the same architect who designed the Vancouver Library and Quebec City's Musée de la Civilisation.

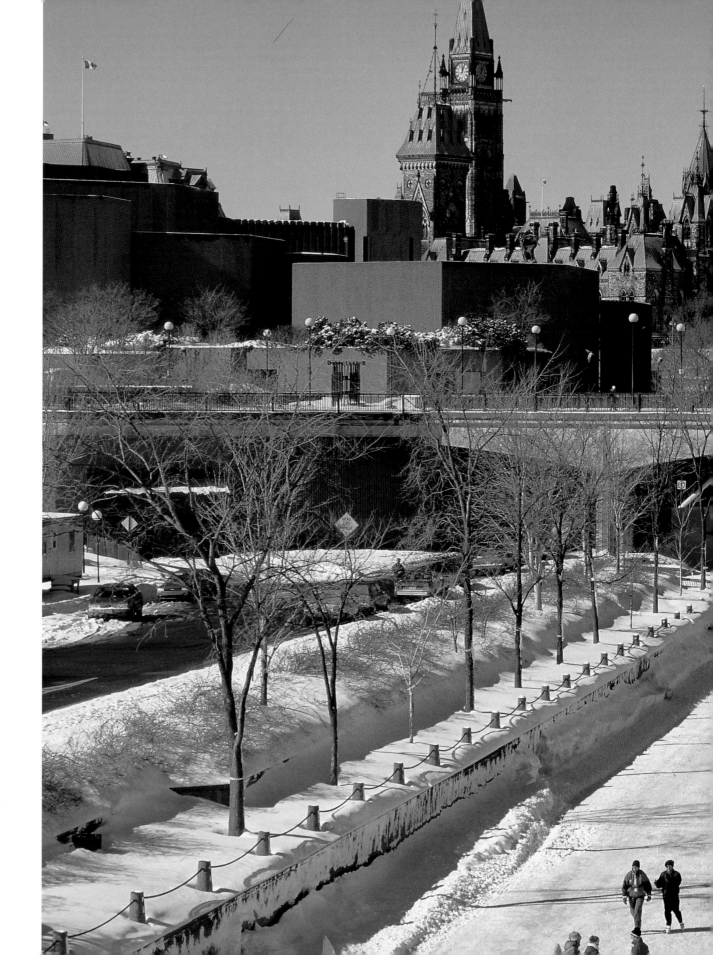

In winter the Rideau Canal is transformed into the world's longest skating rink, with eight kilometres of cleared and maintained ice.

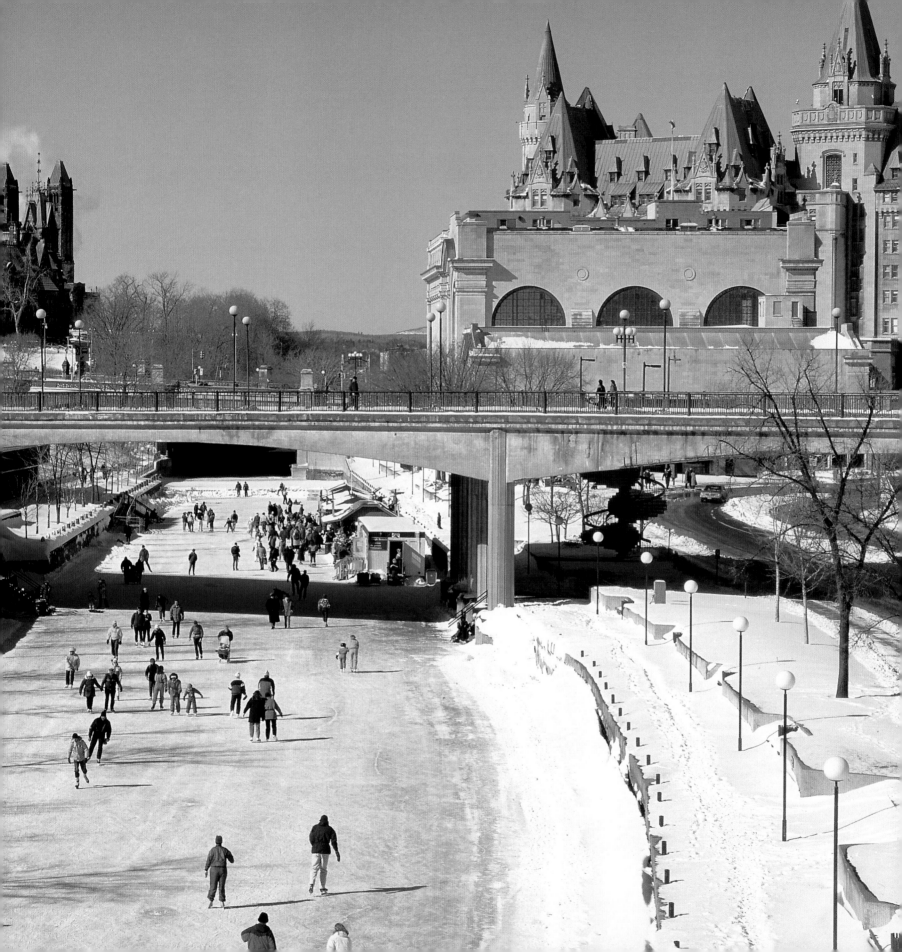

Photo Credits

R. Hartmier/First Light i, iii, 21

Jerry Kobalenko/First Light 6-7, 27, 38-39, 47, 48, 65

Mike Grandmaison 8, 24

Darwin Wiggett 9, 18-19, 29, 78

Michael E. Burch 10-11, 62, 74

Brian Milne/First Light 12, 13, 17

Thomas Kitchin/First Light 14-15, 16, 20, 46, 52

Pierre Guevremont/First Light 22-23

Mark Burnham/First Light 25, 26

Alan Marsh/First Light 28, 30, 31, 49, 50-51, 58, 59, 60, 61, 64, 66-67, 68, 69, 72, 76-77, 82, 83, 84-85

Ken Straiton/First Light 32, 44-45, 56, 57, 70-71, 75, 86, 87

G. Black/First Light 33

Wayne Lynch 34

Janet Dwyer/First Light 35

Jessie Parker/First Light 36-37, 93

Benjamin Rondel/First Light 40-41, 54-55, 90-91

Ron Watts/First Light 42, 92

Bernd Fuchs/First Light 43

David Prichard/First Light 53, 63

Alan Sirulnikoff/First Light 73

Donald Standfield/First Light 79, 80-81, 88-89

J. Cochrane/First Light 94-95